50 Gems
of the
Yorkshire Dales

MIKE APPLETON

AMBERLEY

For Millie

First published 2015

Amberley Publishing
The Hill, Stroud
Gloucestershire, GL5 4EP

www.amberley-books.com

British Library Cataloguing in Publication Data.
A catalogue record for this book is available from the British Library.

ISBN 978 1 4456 4560 5 (paperback)
ISBN 978 1 4456 4568 1 (ebook)

Typesetting and Origination by Amberley Publishing.

Printed in Great Britain.

Contents

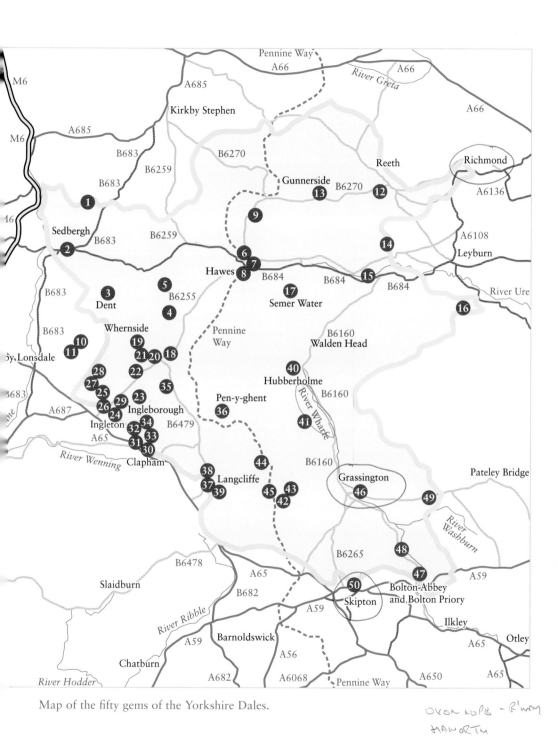

Map of the fifty gems of the Yorkshire Dales.

Diamonds Truly Are Forever

Defining a 'gem' is as much down to personal choice, affiliation and affection as it is to conform to a set checklist of what beauty or a landmark should be.

We can all identify an icon, a symbol, an area of outstanding natural scenery; in fact we do it every day in the choices we make. Holidays are often based around lakes, mountains and ravines; drives and cycles in the country end up in fantastic pubs or cafés; we can all name a stunning vista from our childhood.

The Yorkshire Dales is my gem. I have walked, photographed, caved and camped across its fells all my life. In recent times that love has been transformed into narration and the ability to use the knowledge I've gained, foot by foot, step by step, in language.

I thought I understood why I loved the national park so much; it's easy to see when you're on the top of Pen-y-ghent looking over to Morecambe Bay or seeing the birth of a lamb in a blowing gale. It's a devotion that doesn't even waver when ice-cold water from a cave seeps into an over-suit when you're flat out in a stream.

But that adoration was tested to the full when I was asked to photograph, capture and name fifty of the best places in the Yorkshire Dales. Quite simply, for an area that has so much natural beauty, how can you choose one particular 'sight' over another? How can you rank a gem? In a time of bucket lists and must dos, how do you choose the 'big' numbers, the scenery that everyone must see? What happens if the smaller fells, a rock in an odd place or setting should be on the sheet too?

In the end I had to make a choice as I wanted the gems to be as personal as possible. They needed to connect me to the landscape I know and love so much. They are my fifty and as a result there had to be a certain amount of trade-off to make sure I drafted a list I could be happy with.

And one I could be proud of you visiting.

For instance, towards the final stages of putting this book together I took a stroll from Sedbergh to Cautley Spout with the intention of climbing up the side of the waterfall and eventually crossing over the top to The Calf. But if I had

done so, I wouldn't have been able to fit in Sedbergh itself, which is a gem of a book town.

I have covered most of Ease Gill on foot over the years on my own and with my father and felt it could only be a true gem if it was split in two. There are simply too many places on this walk to select one place or one site. However, in making that decision, it meant it would be difficult to include Gragareth in my list – and let's be honest, that is a real gem too. But I am drawn to Ease Gill time after time and had to make a choice.

I know that technically Ease Gill isn't in the Yorkshire Dales National Park, but it will always be part of Yorkshire for me and many people. It is a stone's throw from the boundary and I'm sure you will understand my granting geographical licence for this gem and also Skipton Castle too. That is, of course, the gateway to the Dales.

Some of the places on my list were visited for the first time, virgin territory, when I was researching the book. I had a lot of advice, must see places and personal favourites from many people in the Dales. Some were obviously beloved connections with the landscape while others were pure oddities. They opened my eyes away from my usual stomping grounds and I'm most grateful. Without this support I would have been lost, stuck in my eyes only, unable to get more from the Dales.

Unless otherwise stated, the photographs were all taken by myself; however, thanks goes to Wensleydale Creamery, Bolton Abbey, Skipton Castle and the landlord of The George Inn for allowing me to take photographs at their sites.

In no particular order I'd to thank Kirstie for her total patience and unwavering support during the course of this project, her driving skills and her ability to find pubs that serve genuine organic cider; Gareth Wright; Bernard Platt; Nigel McFarlane; Andy Jackson for his fantastic picture of Gaping Gill; John Conaughton and William Bagshaw at White Scar Cave; Kirk Fanshawe who was lucky enough to be on Buttertubs when the Tour de France came by; Richard Bowerman at Stump Cross Caverns and Andy Aughey who provided the fantastic image inside the cavern; Bob Jarman at Ingleborough Cave; the tenants of Braithwaite Hall; Stephen Oldfield for his superb help, advice and pictures; and Johnny Hartnell from Inglesport for providing inspiration. Johnny not only gave up his time to take me caving, but became a true friend in the process. He is a gem.

So here I present my gems, my tick list, bucket list, personal interactions, call them what you like, of the Yorkshire Dales. Enjoy them at your leisure.

Mike Appleton, May 2015

A Note ...

For clarity, and ease of visiting, the gems are displayed in four loosely defined 'sections' – north-west, north-east, south-west and south-east.

These boundaries are not 'official' and have been drawn using a certain amount of licence from the author. Some of the locations of the gems on the adjoining map are approximations; therefore, within each description are detailed ways of finding it and, in some cases, an OS Grid Reference.

The best OS maps to explore this area are: Southern and Western (OL2), Northern and Central (OL30) and Howgill Fells & Upper Eden Valley (OL19).

North-West

1 Cautley Spout

It's easy to see why Cautley Spout is much loved in the Yorkshire Dales National Park.

It is England's highest cascading waterfall above ground, as Cautley Holme Beck travels some 200 metres down the fells to create a view more than worth the effort it takes to walk to its base.

It was formed when glaciers retreated into the mountain to effectively force a stream over the edge of the huge Cautley Cragg.

While you can walk to the Spout from Cautley, the best way to take in its splendour is from Sedbergh. It's a lengthy walk there and back, taking in The Calf too, but well worth it. Turning left when you leave the national park's car park in the centre of the town, you join Long Lane before your route passes through Thorns Lane, Underbank and Ellerthwaite.

This soon becomes a green lane with the River Rawthey on your right and, further along, beautiful, if somewhat brief, waterfalls. The length of the walk can test your mental strength – and staying power – as you take the green lane and hug the side of a rising hill; you then begin to drop down for an eternity and wonder if the Spout will ever come into view. But then you turn left and see Cautley Cragg rising. It has much the same effect as Gordale Scar, which you will read about later in this book.

Taking the path onwards to approach the Spout, it seems like a trickle from a distance and then the magnitude of the scene unfolds in front of you with each step. The waterfall could be miles away and part of you wants to run to it, but you just cannot fail to slow to a stroll so your senses can take in the nature before

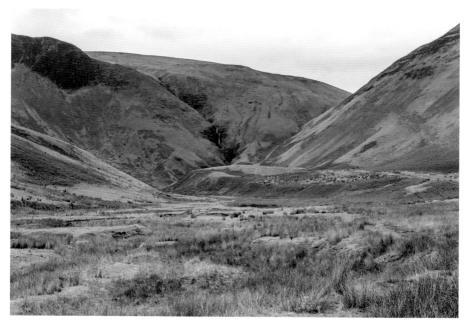

Cautley Spout in the distance ... it seems like an age before you arrive and welcome the landscape around you.

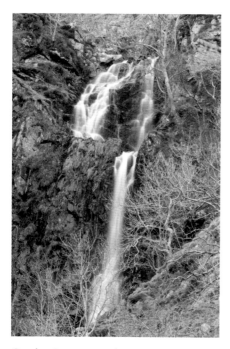

Cautley Spout cascades.

you. Getting closer it's still difficult to focus on the several cascades and rushing water; you're forced to simply sit down on the rise just before the waterfall and muse.

Interestingly, the falls were the hub of a settlement more than 2,000 years ago. Excavations have discovered the houses and fields systems of an Iron Age community in the valley. A stone-edged track led from the settlement to the base of the falls, but went no further. It's easy to see how those falls could have been special or even spiritual for the community.

Once you've taken in your fill, scale the steep path on the right hand side of the waterfall and take the route at the top to The Calf. You then

follow the track to Calders and down to the welcoming town of Sedbergh. A wonderful walk.

Details

As stated, you can take in the Spout from Cautley on the A683, but it is best enjoyed from Sedbergh. It is a walk that is roughly 10 miles circular, but well worth it.

2 Sedbergh

Near the wonderful Howgills, The Calf and Cautley Spout ... full of great cafés and bookshops that cater for all genres and tastes ... Sedbergh has it all.

This ancient market town has a church that dates from the twelfth century, the remains of a castle believed to be from Saxon times, several old houses and buildings – one dating from the fourteenth century – and Sedbergh Boys School.

But for those bibliophiles who prefer to while away the hours in the shops and search out the perfect book, then Sedbergh is your gem.

As England's book town, it brings together a number of bookshops, predominately second hand, to attract people who want a particular tome or are searching for something unique.

The idea to make Sedbergh a book town came after the 2001 foot-and-mouth outbreak effectively closed off vast parts of the Dales. Sedbergh, like most villages and towns, suffered.

Two years after the crisis ended, a company was set up to bring the literary businesses in the area together with the aim of helping each other and promoting their fine work. The number of shops and outlets grew over the next three years, as did the number of local writers and people involved in publishing, and in May 2006 it was officially recognised as England's Book Town when it was elected into the International Organisation of Book Towns.

And that recognition is seen by the sheer numbers of shops in Sedbergh.

If reading isn't your bag then it is worth combining a visit to the town with a trip into the Howgills. The Calf is nearby (SD667970) and on a clear day

the vista is not only a panorama of the surrounding mountains but also the Lakes, Eden Valley and North Pennines too.

The direct route up from Sedbergh is the most popular, so it is worth considering walking out to Cautley Spout and then coming back round to The Calf and Calders before descending back to the town (the route described in gem 1).

Details

Sedbergh is on the A684, from Junction 37 of the M6.

Sedbergh – England's Book Town.

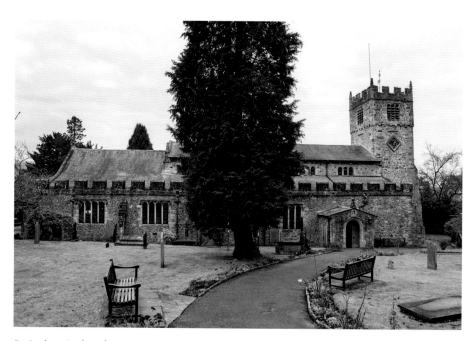

St Andrew's church.

3 Dent

I owe so much of my love of the Dales to the time I spent as a youngster in Dent.

The small village with its narrow cobbled streets, river, and gorge climb were a playground for an inquisitive ten year old with an active imagination.

And these days it is still as attractive as it ever was.

Dent is around 5 miles east of Sedbergh, but its remote nature doesn't stop the thousands of visitors who each year come to view its treasures.

Historically, knitting was a popular cottage industry in the Dales, and the Terrible Knitters of Dent were well known in local circles. This referred not only to the speed at which garments were put together but also the way protagonists of the craft would rock back and forward while removing the loops. Men would join women and children knitting too. Visitors can see the 'picks' used in this industry in the fantastic Dent Village Museum & Heritage Centre, which is on the left as you leave Dent towards Sedbergh.

Dent was also the birthplace of the geologist Adam Sedgwick (22 March 1785) one of the founders of modern geology. He suggested the Devonian and Cambrian periods of timescale and worked with the young Charles Darwin in his early study of geology. A large 'rock' monument is sited just opposite the George and Dragon pub to commemorate his birth.

Walking into the village itself it's easy to see why it is so popular. It is narrow, looks somewhat like a film set – although never used as one to my knowledge – and is charming. It's probably not much different to what it was hundreds of years ago. It has two great pubs, the Sun Inn and the George and Dragon, the latter of which is the tap house for the Dent Brewery. Heading towards the River Dee and Church Bridge you can also join the Dales Way. Go in the opposite direction, with the George and Dragon on your left, and then turn right and past the playground; it is possible to climb up Flintergill and join the Nature Trail.

As with most villages, the church is an obvious focal point and dominates in terms of size the buildings in the centre. St Andrew's was constructed in the twelfth century, rebuilt in 1417, restored 173 years later and again in 1787. Outside its porch is a curious gravestone of the vampire George Hodgeson.

In 1715, George died but apparently began making regular appearances in the village. Folklore suggested that he enjoyed a daily glass of sheep's blood as a tonic, and a farmer said he had shot a black hare and followed a blood trail that led to George's door. On peering through the window he saw Mr Hodgeson tending a shotgun wound …

The cobbled streets of Dent.

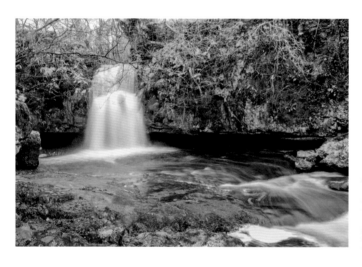

The waterfall around 3 miles before Dent village as you travel from Kingsdale.

Eventually, the consternation in the village was too much and George was exhumed, a new grave dug at the door of the church and a brass stake driven through his body.

And you can still see the top of that stake today.

Details

Dent can be reached in a number of ways. You can come in from Sedbergh as well as the signposted route off the B6255 from Ingleton and Hawes. A road through Kingsdale out of the back of Ingleton is a fantastic introduction to the wildness of the Dales as well.

Both pubs are open throughout the year and the Dent Village Museum & Heritage Centre is open seven days a week from 11 a.m. until 4 p.m.

4 Dent Head Viaduct

While many of the visitors to the Dales will understandably head to the iconic Ribblehead Viaduct, there is an equally impressive structure on the doorstep.

It may not be on the scale of the twenty-four-arch structure in the shadow of Whernside, but it is more secluded and less frequented, making it an ideal gem.

Like its bigger brother, Dent Head Viaduct carries the Settle–Carlisle line and spans some of the most remote countryside in England. It was built under engineer John Sydney Crossley between 1869 and 1875 for the Midland Railway Company out of Dent marble. Crossing the quarry that produced it, it has ten arches, is 100 feet high and is just shy of 200 yards long. Underneath lies a stream that makes its way to the River Dee over almost jet black rock and an impressive 'pack horse' bridge that perfectly frames the scene.

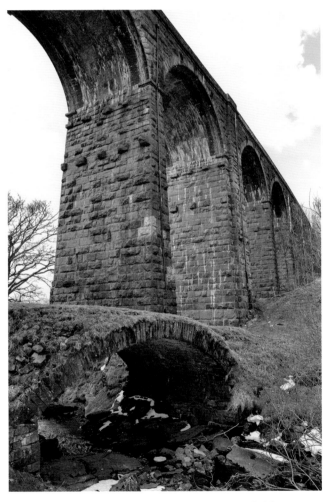

Details

Dent Head Viaduct is on the road to Dent from the B6255. It can be visited at any time of the year. Grid ref.: SD777845.

The Dent Head Viaduct during winter, surrounded by melting snow.

5 Dent Station

'Let the train take the strain' is a mantra used by railway operating companies and those of a more sensible nature who are sick of being stuck in traffic at all hours of the day.

At a height of 1,150 feet above sea level, Dent station is the epitome of the perfect rail journey; the engine makes its way through stunning countryside for you to disembark immediately to views across Dentdale and beyond. Trains drop off here around five times a day and walkers and cyclists will make their way down the steep road towards Cowgill and adventures beyond.

Dent station was first opened for the public on 6 August 1877 and operated for more than ninety-three years until it was closed in 1970 as part of the swingeing cuts to the rail network. It re-opened in 1986, although the station itself was sold to Neil Ambrose by Railtrack. Neil was a railway enthusiast as well as an engineering development manager for a Canadian company that built trains in the UK. He had only wanted to find a country house, but after failing in a bid to find another station, he looked at Dent as a possibility.

He restored the station and buildings and in 2006 Robin Hughes took over employing local people to continue its restoration and make its unique buildings

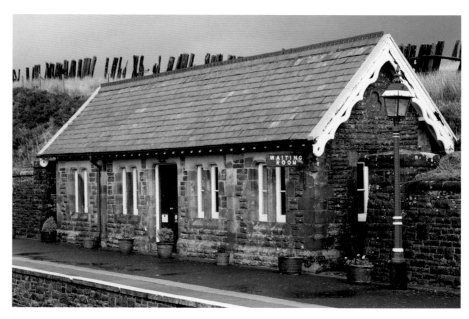

Dent station waiting room – with its snow fences just hiding behind.

available for people to let as holiday accommodation. The station itself, as well as the Snow Hut/Bunk Barn and Snow Hut 3, is available to stay in.

The station itself is more than a nod to the railway heritage of the Settle–Carlisle line and is beautifully presented and maintained. As it is well above sea level, fences were erected using old railway sleepers to keep snow off the tracks. Yet a quick internet search will see pictures showing the station completely snowbound, and, indeed, in 1947 and 1963 no trains could get to the station.

At its peak, more than ninety trains would use it, but things are much more sedate now. It is a perfect place to stop and muse upon life.

Details

Obviously, the best way to visit the station would be via rail from either Leeds or Carlisle, and there are roughly five trains per day that stop there. By road it is on the old Coal Road that links Garsdale Head with Cowgill. From Garsdale Head take the A4684 or follow the B6255 and take the signs to Dent. The road up to the station can be affected by the weather in the winter.

6 Hardraw Force

Pub ... waterfall ... what more do you want?

The highest single-drop waterfall in England, Hardraw Force is set in the village of Hardraw in a wooded area of land behind the Green Dragon Inn, which dates back to the thirteenth century.

Water flows over Hardrow Scaur limestone and falls some 100 feet, unbroken, into an amphitheatre of noise. As with most waterfalls, it is best viewed after heavy rain, and it is possible to walk behind it on dry days. The ravine that houses this impressive sight is also a gem, being the setting of ancient woodland that houses many species of birds and wild flowers.

The waterfall itself plunges over carboniferous limestone, past sandstone and then into shale, which forms the bed of the river and pool. In fact, the rock structure behind the falls shows the layers of limestone, sandstone and shale that were built up over millions of years; the stepped effect that can also been seen in the falls at Aysgarth.

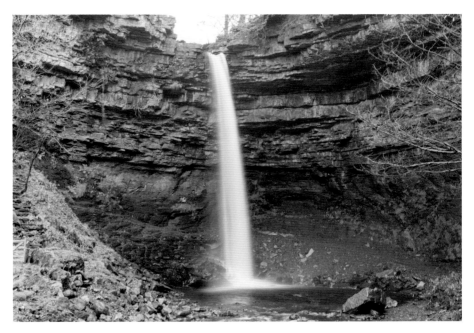

Hardraw Force, best viewed when it's raining.

And after visiting the fall, the pub comes into its own.

Hardraw comes from the old English for 'shepherd's dwelling', and the land was once owned by Cistercian monks who kept a grange in the village. According to the pub's website, early northern (Yorkist) kings would rally their troops at known locations such as 'at the banner of the Green Dragon, near the waterfall'. It is possible that here lies the origin of the inn's name, and the pub's sign does indeed show a green dragon and a white rose.

The public bar area dates to the fourteenth century and, in keeping with the historical nature of the entire site, has been restored superbly by D. Mark Thompson. However, at the time of writing it was up for sale as he plans his retirement.

One last fact: Hardraw Force was famously used by Kevin Costner's 'bum' double in the film *Robin Hood: Prince of Thieves*, when Maid Marian catches Robin bathing under a waterfall.

Details

From the Green Dragon Inn website (www.greendragonhardraw.com):

The Waterfall is open daily (10 a.m. in winter and 8 a.m. in summer) until dusk. Entry is £2.50 per adult and £1.50 per child with free entry for under fives. A group ticket for two adults and two children is £7.50. There are also several events that make best use of the Scaur including a Brass Festival. Grid ref.: SD869917.

7 Hawes

The name 'Hawes' means 'a pass between mountains', and as it stands between the breathtaking Buttertubs and Fleet Moss, it's easy to see why the village is a must-see for so many visitors who come to the Dales.

It is the hub for the wonderful Wensleydale Creamery, Dales Countryside Museum – which is sited at the former Hawes railway station – and, outside the town, Hardraw Force, as well as a number of great shops, tea rooms and pubs. The Pennine Way passes through it too.

Historically, the town was first recorded as a market place in 1307 and was granted its market status when Gayle schoolmaster Matthew Weatherald acquired it from King William III. The market still exists today on a Tuesday in the market hall, while a number of other stalls are in the market place.

While most of the buildings from that period of history have not survived, there are some that are more than 300 years old, including both restaurants, which retain their seventeenth-century features.

The St Margaret of Antioch church in Hawes.

Taking a wander around the town there are some buildings that show the pre-market town status of Hawes – Crockett's is probably the most obvious and well worth a visit. It was formerly an inn and the date over the door suggests it was certainly in use in 1668. It was bought by Quakers less than a hundred years later as a rest house, and it was a condition of tenure at the time that penniless travellers had to be taken in and helped.

In 2014, the town also welcomed the Tour de France as the cyclists passed through on their way from Leeds to Harrogate.

Details

The Creamery is detailed elsewhere in this book. The Dales Countryside Museum is open daily from 10 a.m. to 4 p.m., with an entry charge of £4 for adults, £3.50 concessions and free entry for under sixteens and students.

8 Wensleydale Creamery

Some people would find it strange to have a modern-day working factory listed as a 'gem'.

But in the case of Wensleydale Creamery it seems only apt as it is world renowned, at the hub of the village of Hawes, and you can sample free cheese.

Wensleydale Cheese was first made in the twelfth century by a group of Cistercian monks who settled in the area. It remained a cottage industry, a local secret, until large-scale production began in Hawes.

Depression in the 1930s almost forced the dairy to close, and if it wasn't for local businessman Kit Calvert, who mobilised local support, then it wouldn't be what it is today. He kept it going until it was sold to the Milk Marketing Board in 1966 only for them to close it twenty-six years later and transfer production to Lancashire – perish the thought!

But management bought it out in the same year and created the fantastic product and site it is at present.

Many dairies make Wensleydale, but Yorkshire Wensleydale has Protected Geographical Indication (PGI) status. That ensures no other cheese maker outside the area can make cheese and name it Yorkshire Wensleydale – and it's a good thing too as the creamery at Hawes is one of the best cheese markers around.

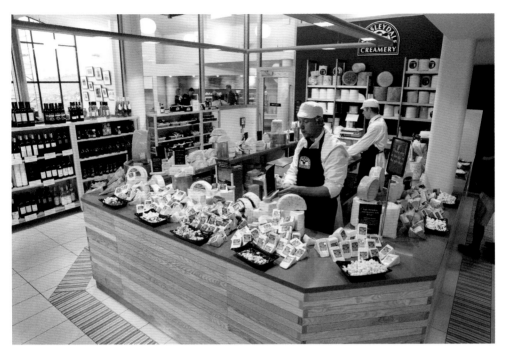

Turophiles rejoice! The selection of cheese on offer at Wensleydale Creamery.

The creamery uses local milk from local farms and has blended its cheese with a number of other tastes and flavours including cranberry, apricot, garlic and, my favourite, pesto. It has more than 400 awards for its products, which also include Double Gloucester and cheddar as well as sheep's cheese.

As well as touring the factory and watching the cheese-making process, you can sample it profusely in the cheese shop before buying as much of the yummy product as you like.

The cafés on site are excellent and have a relaxed atmosphere, which is shared by the whole site. It is definitely worth a visit.

Details

Wensleydale Creamery is found on Gayle Lane in Hawes (Dl8 3RN) and is well signposted.

The best time to see cheese being made is between 10 a.m. and 2 p.m. The Cheese Making Viewing Gallery & Museum is open Monday to Sunday 10 a.m. to 4 p.m. The price of entry to the museum is £2.50 for adults, £1.50 for children and free entry for under fives. A family ticket is £7.50 (two adults and two children).

www.wensleydale.co.uk.

9 Buttertubs Pass

Mountain passes like Alpe d'Huez and the Col du Tourmalet are famous the world over, not only for their iconic scenery but their gruelling difficulty in the Tour de France.

In 2014, the cyclists on the famous race got the opportunity to ascend a must-see and must-ride in England – the Buttertubs Pass. It came at 103 kilometres in the 190.5-kilometre stage from Leeds to Harrogate, a 4.5-kilometre climb at 6.8 per cent gradient.

The view as the riders climbed the pass was stunning, and the crowds were sometimes fifty people deep creating an Alpe d'Huez atmosphere in Britain. Fans ran alongside the riders. The noise was deafening.

It was estimated that tens of thousands of people were on that pass on 5 July,

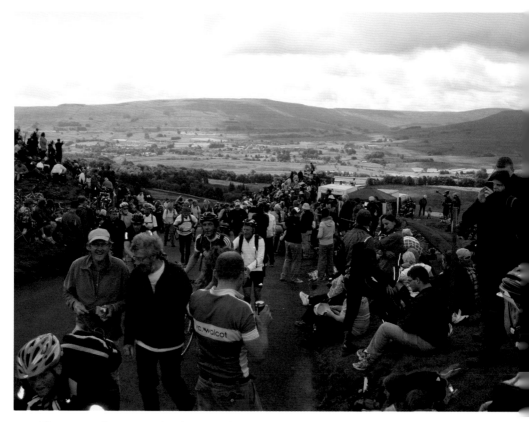

The Buttertubs prepare for the visit of the Tour de France. (Kirk Fanshawe)

providing a moment that will surely earn England another Grand Départ in the future.

The Buttertubs Pass winds its way from just outside Hawes towards Muker past fluted potholes which give it its name; the potholes are 15 to 20 metres deep, fluted by water flowing down the walls, and it is thought farmers would lower butter into the holes to keep it cool when they travelled to market on a hot day.

Details

Buttertubs Pass is on the road from Hawes to Thwaite and Muker. Grid ref.: SD875961.

10 Ease Gill

While not technically in the Yorkshire Dales (Ease Gill lies on the Cumbria–Lancashire border), it would take a brave person not to allow an area with around 90 kilometres of cave passages to be considered a gem – especially as it is a stone's throw from the national park's border.

Ease Gill is part of the Three Counties System – the longest and most complex cave system in Britain – which is underneath the Casterton, Leck and Ireby Fells around the 2,057-foot hill named Gragareth. Passages exist on many levels, and there are a multitude of entrances, so route finding requires experience and plenty of prior knowledge.

Taking the path from Bull Pot Farm, you pass Bull Pot of the Witches on your right – an obvious tree-lined depression. This in itself has more than 2½ kilometres of passage.

Shakeholes, where the ground has given way because of subterranean activity, lie all along the path, and you pass Hidden Pot and Gale Garth Pot before turning left to head to Cow Pot. There, the limestone appears pink in certain light and descends some 23 metres down into the depths and link up with other parts of the Ease Gill system. Following the path to the dry riverbed you are transported to a place of silent reverie where heather, bracken and trees all grow without human intervention. It is serenely peaceful. Following the stream bed to the left, you go past a number of various shafts and drops, some hand-lined with ropes for use by cavers, others long since abandoned, before you reach Cow Dub

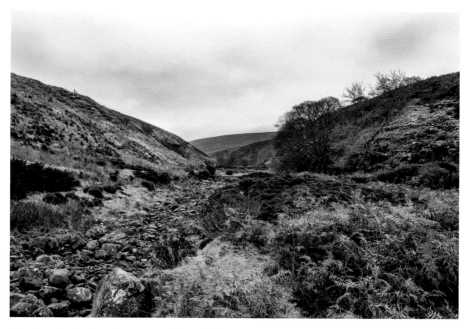

The dry riverbed on the way to Ease Gill.

and the beautiful waterfall encased in rock. Climbing up the right-hand side you come out into Ease Gill itself.

The caves on the right don't go very far but can be explored with a torch; the lidded shaft on the left, however, is County Pot and that shouldn't be entered as it goes into the depths of the system. Further up the ravine are a number of cracks and holes that take Ease Gill's water in flood. The stream bed has fossils and interesting rock shapes carved out by the water. Continuing upwards you will pass Corner Sink, Wretched Rabbit, The Borehole, Boundary Pot and, eventually, come out on to the moor at Top Sink.

There's no doubt the caves up at Ease Gill – though not necessarily those mentioned above – were known well before the extensions of the system. In 1936, exploration in Ease Gill found seven sinks. In the late nineteenth century, Bull Pot and Cow Pot were mentioned in contemporary writings, and it was said the former could be 'descended down to its downstream sump over 200ft below without any tackle if care is taken'.

However, it was the discovery of Lancaster Hole in 1946 that proved to be the real jewel in the crown. After resting following a trip into Cow Pot, George Cornes and Bill Taylor noticed a small draft causing grass to move nearby. It opened into a 34-metre shaft and the discovery of miles and miles of passages on various levels upstream to even more inlet passages. A real find … and exploration is continuing.

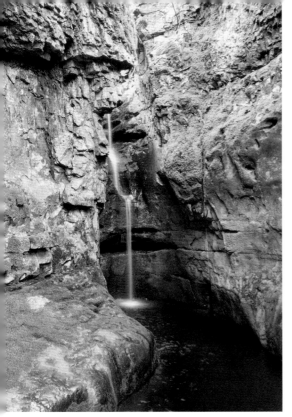
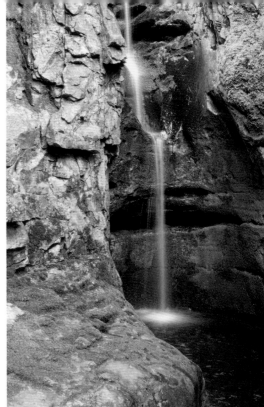

Cow Dub waterfall at Ease Gill.

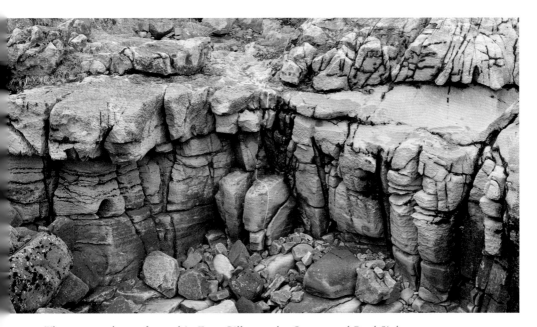

The strange shapes formed in Ease Gill near the Corner and Pool Sink caves.

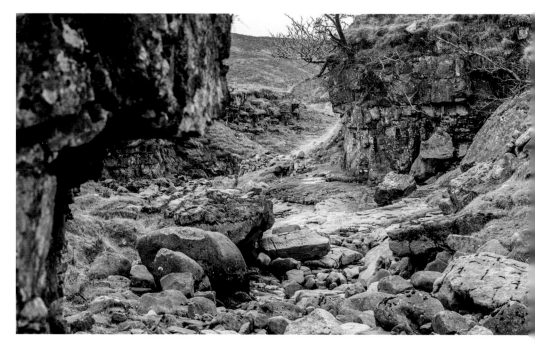

As well as the caves, it's an impressive site above the surface too.

A couple of years back, Lost Johns and Notts Pot were joined by digging a tunnel, which meant that it was possible for a caver underground in Cumbria to travel below Lancashire and emerge in Yorkshire.

While those with more sanity than subterranean specialists can't enjoy trips like that, Ease Gill is certainly worth a visit to get an idea of what lies beneath.

Details

There is no easy way to Ease Gill but the walk is well worth it.

Park at Bullpot Farm, Casterton, Carnforth LA6 2JP and follow the obvious path, turning left at the stile after the path rises. This takes you to Cow Pot (fenced on the left) with Lancaster Hole a few yards down the valley on the right. You then take the path over the 'hump' and when it reaches the dry riverbed, turn left.

Alternatively, leave your car on the road from Barbon to Dent, just after Blindbeck Bridge where the road levels out, and make your way over the bridge and up the hill using the second track on the left. This track soon becomes wider and takes you to Bull Pot Farm.

The dangers of the caves in this area are obvious. The potholes descend to serious depths and sudden flooding is always a distinct possibility. Caving is by permit only and the nooks and crannies shouldn't be entered.

11 Ease Gill Kirk

While not as dynamic underground as its Upper Ease Gill brother, Lower Ease Gill is a real explorer's heaven with nooks and crannies, water appearing from nowhere and, perhaps more importantly, hardly any people.

Lower Ease Gill is a misnomer but it's used here to distinguish it from the caves at the top end of Ease Gill. Just to complicate matters, it should be known as Ease Gill Kirk – but that is split into upper and lower levels too! My advice is to just walk down to Hellot Scales Barn and explore.

Ease Gill Beck was carved out by meltwater at the end of the last glaciation as the ice retreated. As the Beck progresses down the valley the water is underneath, finding its way through the miles and miles of subterranean passages before it reappears, under great pressure, as it hits impervious rock at Leck Beck Head.

Instead of the water appearing in the obvious stream bed – the linear Ease Gill Beck route – it is forced out of a side resurgence, which can be very dramatic in flood.

Once you've viewed this, you can walk up to lower Ease Gill Kirk and view the many caves in the walls on either side. There are eleven in total. They are fairly safe to enter, but first it is worth walking a little further down from Leck Beck Head and viewing the waterfall and plunge pool.

Left: The usually dry waterfall just upwards of Ease Gill Kirk. It certainly isn't dry when it floods …

Right: … as can be seen from the water patterns and fissures in the rock.

In the west bank of the channel, just below the Lower Kirk Caves, is the Witches Cave, which is impressive in flood as water powers out of its entrance. It was first explored in 1849 by Henry H. Davis, who said it was 80 yards long before a pool was encountered, but it's actually only 80 feet before it becomes passable only to cave divers. You can enter in dry conditions and it certainly has an eerie feel to it.

Walking up from the Lower Kirk is Upper Ease Gill Kirk and a U-shaped waterfall with cliffs on the left and right. I have often lain on my back in this amphitheatre looking up and taking in the scene. While it is normally dry, the obvious water marks in the rock show how it floods to a frightening height and the power that water carries. But most of the time, people-free, you can enjoy this without the threat of flooding and listen to the birds that call it home.

Details

Park at Bullpot Farm, Casterton, Carnforth LA6 2JP and follow the obvious path to Hellot Scales Barn. From there you can either take the steep path down to just below the base of Upper Ease Gill Kirk or go to the right of the barn and head to Leck Beck Head. You can then follow the stream up.

Once more, although it is possible to enter some of the caves here, you need to be fully aware of the dangers involved. Ease Gill can flood at any time.

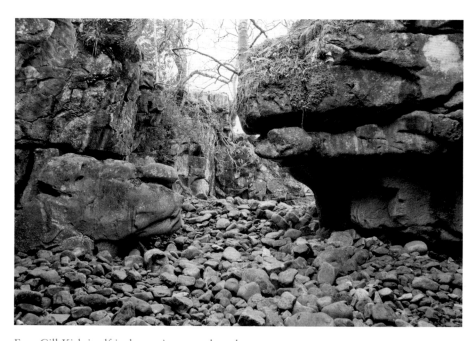

Ease Gill Kirk itself is dramatic even when dry.

North-East

12 Reeth

Of all the villages visited by the 198 riders on the first English leg of the 2014 Tour de France, Reeth probably took the race to heart more than any other.

Hundreds of people lined the single route through the village, finding vantage spots that included local bus shelters, walls and skylights, cheering on the cyclists, while local businesses bedecked their frontages in homage to the 101st version of this iconic event.

Of course, many other communities did the same, but the sight of the local post office some four months later, still resplendent in its polka dot paintwork, shows Le Tour possibly had more impact here than most.

Classed as the unofficial capital of Swaledale, Reeth is another village where its triangular green is king. The village is noted in the Domesday Book, and, as well being a market centre for the local community, was a hub for knitting and lead. Nowadays, as well as being home to the Swaledale Museum, which has some fantastic displays on local life and archaeology, and cafés that sell local produce, it has three great pubs.

The Black Bull in particular dates from 1680 and is the village's oldest pub. You'll notice it because the sign above the front entrance is upside down in an apparent two-fingered salute to national park officials. Previous landlord Bob Sykes attempted to tidy up the exterior of the pub by removing its render to expose the original walls. But the national park threatened legal action if it wasn't replaced because they thought it would have had some kind of render years ago. So, somebody local turned the sign upside down in protest at the

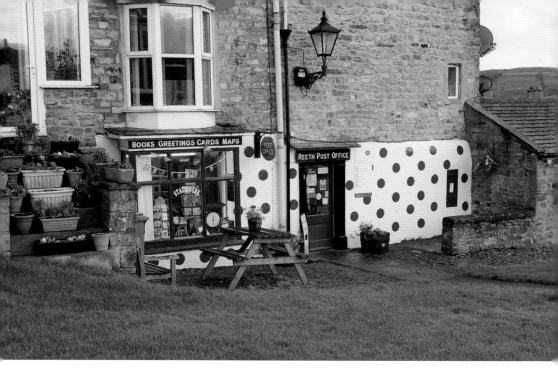

Reeth Post Office celebrates the Tour de France with this spotty number.

attitude of park officials – and although it has moved from its original spot, it's still upside down.

While in Reeth, it is also worth visiting the community orchard that is in the north-west of the village – if you turn left from the Black Bull. There are several sculptures in there as well as the opportunity to buy vegetables grown in the gardens. It is also very quiet, and you can while away the hours underneath the tree that sits roughly two-thirds of the way in.

Details
Reeth is on the B6270 which links Kirkby Stephen to Richmond. The museum is open seasonally and has a nominal entry fee.

13 Gunnerside

For all its beauty, it has to be remembered that the Yorkshire Dales is a working landscape. Long before farming and tourism became the dominant way of

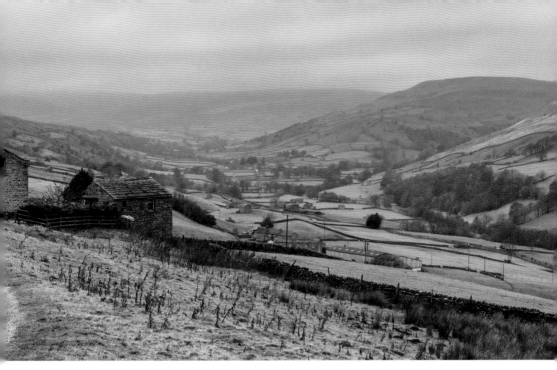

Gunnerside is beautiful, but would have looked very different hundreds of years ago before the landscape was irrevocably changed by industry.

making a living in the region, heavy industry shaped some of the countryside we visit today.

Ribblehead Quarry, now a nature reserve, produced limestone for the iron industry. In fact, travel anywhere in the three peaks and you'll see evidence of quarrying and mining as well as simple things like lime kilns. Horton and Ingleton quarries are indeed still very active sites that are transforming the landscape.

Take a walk around Gunnerside – particularly Gunnerside Gill – and the history of this activity, albeit from hundreds of years ago, is there for all to see. Set in Swaledale, it was the site of a major lead-mining industry that covered a lot of this now picturesque dale.

The valley still contains much of its industrial past with dammed streams and old workings dotted around the gill. Known as 'hushes', there are a number of scars on both sides of the valley, created when water was forced over the soil to expose lead ore, as well as the soil that was driven out of the ground by compressed air drills. This was then crushed for smelting.

As a result, spoil heaps are also in abundance and it doesn't take much imagination to realise what this area and the way of life must have been like when the mining industry was in full flow; they are a stark reminder of the history of this beautiful area.

Gunnerside village doesn't really force this heritage on you, but rather serves as a beautiful base from where to start your tour. It seemed to me that it wanted the

visitor to discover its past for itself. It has a fine pub, and the Old Working Smithy
& Museum is well worth a visit if you want an introduction to that history. The
smithy was established in 1795 and has several superb artefacts on display.

Details

Gunnerside is on the B6270. The Old Working Smithy & Museum is open from
Easter until the end of October from 11 a.m. to 5 p.m. (closed Mondays), and
admission is £2.50 for adults, £1.50 for children up to the age of sixteen and
free entry for under fives.

14 Bolton Castle

For sheer completeness set against a scenic backdrop, it doesn't get much better
than Bolton Castle – or Castle Bolton as it is known on various maps.

It is one of the best-preserved examples of a castle in the British Isles, stunning
and imposing from every angle, with plenty to see and do.

Building began in 1379 after Richard le Scrope, Lord Chancellor of England to
Richard II, was given licence to create a fortress. It took twenty years to complete
and was seen not only as a site of defensive power but was extravagant too,
befitting the status of its owner. There were en-suite toilets and a complicated
chimney system.

For nearly 150 years it survived intact until, in 1536, it was burned down by
King Henry VIII as a punishment for Sir John Scrope's reluctant support of the
Pilgrimage of Grace. Additionally, Mary Queen of Scots was imprisoned there in
1658, and you can visit her bedchamber on the third floor. More than a hundred
years later, it was besieged by Parliamentarian forces during the Civil War, and
the family left the castle for Bolton Hall in 1675.

Nowadays, the castle is open to the public thanks to the extensive preservation
that took place around fifteen years ago. But this isn't just an ordinary tour
around a castle. You can see the malting room and buttery, nursery, great
chamber, battlements and, once outside, gardens and maze. You can also visit the
gift shop and tea room, but the castle offers so much more. There's a falconry, a
wild boar park, archery and other things that show you what medieval life was
all about. And they look and feel very real indeed. The kids will love it!

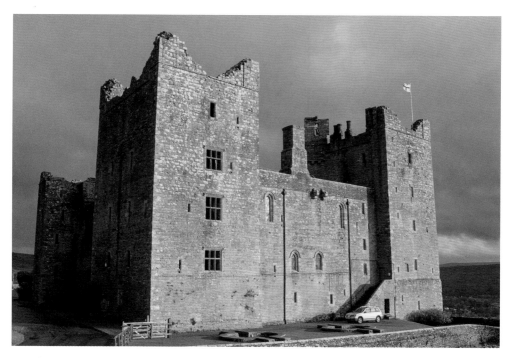

The impressive Bolton Castle.

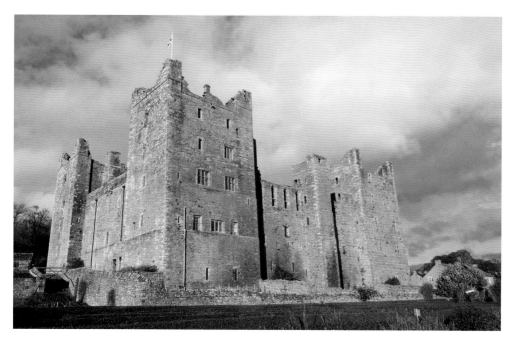

Bolton Castle from the maze.

A tree set in the grounds.

Details

Bolton Castle is near Leyburn (DL8 4ET) and is open from the middle of February to the beginning of October. It is best to check the castle's website (www.boltoncastle.co.uk) for details as it is often the location of films, TV crews and weddings. The cost of entry is also on the website, but for the castle, gardens and grounds it is £8.50 for adults, £7.00 for concessions (visitors aged over sixty, students and children aged five to eighteen) and a family ticket is £30.00 (two adults and up to three concessions which must include at least one child).

15 Aysgarth Falls

Sometimes nature just has the habit of taking your breath away.

The three falls at Aysgarth in Wensleydale carry the River Ure on its way to becoming the River Ouse that passes through York and beyond.

They are spectacular waterfalls, but geology has made them unique and awe-inspiring for all who take them in – especially when they are in full flight. The river flows over limestone some 300 million years old, which has soft layers

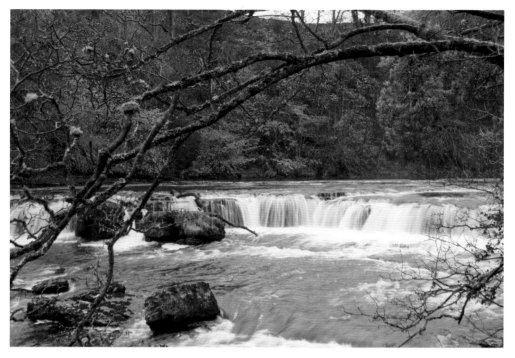

Aysgarth Falls.

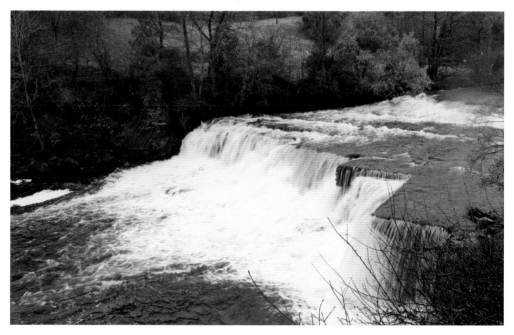

The Middle Aysgarth Falls carry more power than their upper and lower family.

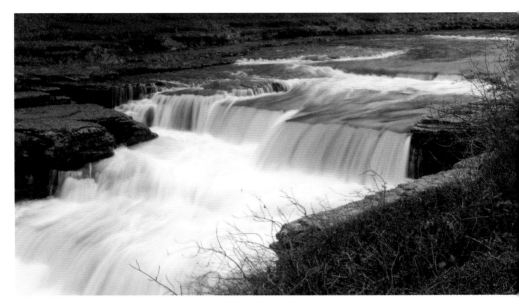

The Lower Aysgarth Falls.

of shale in-between. The water wears away the shale, and the rock above breaks to form steps. That creates the falls and shapes over which the river flows, something that J. M. W. Turner felt the need to sketch in 1816 and the likes of Ruskin and Wordsworth put into words.

The Upper Falls are wide in view and were famously used in *Robin Hood: Prince of Thieves* when Robin received a good old soaking. The Middle Falls can only be viewed from further away but are equally as dramatic and powerful. I was drawn most to the Lower Falls, which to me were more intense. The water flow is narrower, and therefore, in great rainfall, the peat lends hues of brown and purple to bring the powerful sheet of water to life.

In addition to the waterfalls, the walks in-between take in a fine wooded valley – protected as a Site of Special Scientific Interest – where it is possible to see many species of bird and the odd deer. In fact, 'Aysgarth' comes from Old Norse, meaning 'the open space in the oak trees'.

Details

Head to the Aysgarth Falls National Park Centre, which is well signposted. It is open seven days a week with reduced opening in the winter season. It is well signposted from the village of Aysgarth and is an ideal base to explore all three falls. Grid ref.: SE012888.

16 Braithwaite Hall

Braithwaite Hall is a seventeenth-century farmhouse set in beautiful Coverdale, just shy of 2 miles from Middleham. It can only be visited during certain months of the year as it is a working farm, but it has several interesting features on show to visitors including a stone-flagged entrance hall, oak-panelled drawing room and oak staircase.

Braithwaite means 'broad clearing', which is quite apt as the area would have been forest around medieval times. It is a listed building and actually doesn't appear in any records until around 1610. After the Dissolution of the Monasteries in the 1530s, the land was passed to the Crown before it was leased to a farmer. The Ward family took over in the late sixteenth century, followed by Thomas Horner of Coverdale.

Interestingly, the City of London had ownership of the site in the early

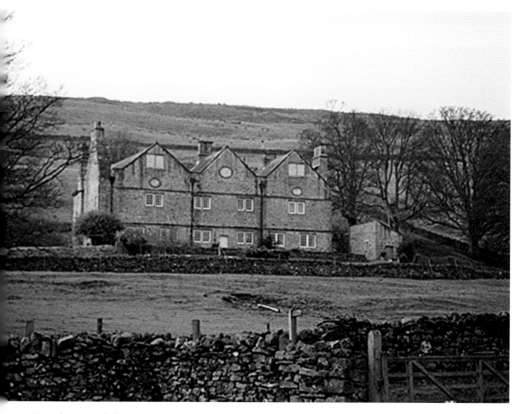

Braithwaite Hall. (National Trust)

seventeenth century, and then, from the 1680s, it belonged to the Wood family from Middlesex, who didn't actually live there. It passed through more owners until it was left to the National Trust in 1940 and the current tenant Mr Charles Duffus.

The hall itself is grand and has been developed during the years it has been occupied. It underwent major changes in 1667 and it is possible it would have been double its size before then. Historical documents suggest it had an extra wing to the south.

It is quite different from other buildings in the area, which suggests the affluence of its owners grew as their commercial interests progressed. In fact, coal, lead and silver have all been mined there. Workings are still evident today, as is a lime kiln, which would have made sure the land was good for grazing.

Braithwaite Moor is a Site of Scientific Interest, a Special Protection Area and a Special Area of Conservation because of its blanket bog and heather moorland. Its wood is impressive too, especially as it houses a number of older trees including oaks, alder and sycamores. The large-leaved lime is scarce in the country but sited here.

Details

Braithwaite Hall is a National Trust property that has a tenant. It can be visited in June, July and August but only by arrangement in advance with the tenant. It lies 1½ miles south-west of Middleham, west of East Witton (A6108). Grid ref.: SE117857.

17 Semerwater

It is thought Semerwater was once a prosperous city in the Dales. Legend has it that an old man (although gender and status change depending on who is telling the tale) came to the city in search of food and drink. He knocked on each door, being rebuked every time, before he found a welcoming hovel where a poor couple pitied him and took him in. After enjoying the couple's hospitality, the old man turned to face the town and said, 'Semerwater rise! Semerwater sink! And swallow the town, all save this house, where they gave me meat and drink.'

Immediately, the waters of the lake rose up and flooded the area drowning its citizens but saving the couple who took him in.

It's easy to see how the open nature and pure beauty of Semerwater could inspire artists, folk stories, poems and music. J. M. W. Turner painted it in 1816.

Semerwater is the second largest natural lake in Yorkshire after Malham Tarn and is around half a mile long. Fed by water from Cradle and the beck around Raydale, its name derives from the Old English meaning lake, mere and water. It was formed, or dammed, when moraine was deposited as a glacier retreated. Water did find a way out of the drift eventually, cutting the course of the River Bain, England's smallest river at 2 miles long. The lake's water finds its way to the River Ure at Bainbridge. Originally, the lake would have stretched up Raydale, some 2½ miles.

At the lake are three large granite stones known as the Carlow Stone and Mermaid Stones, which were deposited on the site from Shap by the ice flows.

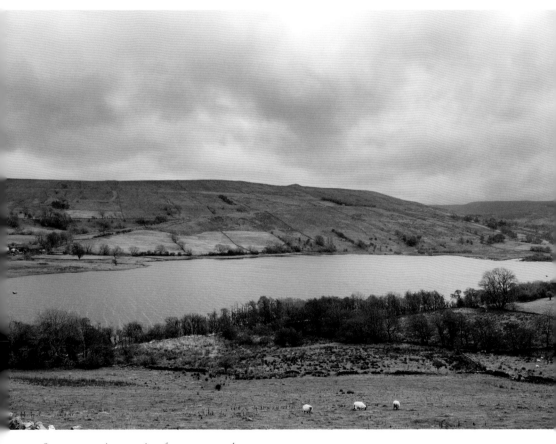

Semerwater is stunning from any angle.

Unsurprisingly, there is a legend around the former stone. Apparently, a giant on Addlebrough threw stones at the Devil on neighbouring Crag Hill. The Carlow Stone is one that was dropped by the giant, although it is also said that it was thrown there.

If you go to the Dales Countryside Museum in Hawes, you can see a Bronze Age spear head that was found at the lake, and excavations have also found an Iron Age settlement. 10,000 years ago Stone Age man used the lake to hunt because herds of deer and wild horses gathered to drink there.

Whatever the legend and history, Semerwater is rarely busy and therefore is the perfect place to ponder life and watch the many birds that visit its shores.

Details

Semerwater can be found if you approach Bainbridge on the A684. Before the village you can turn left and follow the road to Semerwater, which should be around 3 miles. If approaching from Hawes then you go through Burtersett and Raydale. Car parking charges are £1 for two hours, £1.50 between two and five hours and £2 to park all day. Motorcycles and scooters are charged 50p. It is also possible to camp at the site. For further information, visit Low Blean Farm near to the lake.

South-West

18 Thorns Gill

This gem of a ravine takes you off the beaten track, and, for those who don't mind getting wet feet and want to satisfy their adventurous side, there is the possibility of making a trip into an active and very young cave system.

The best way to take in Thorns Gill is from Ribblehead. It's simple enough to leave your car there, or you can get off the train at Ribblehead station and view the viaduct before heading up the road to Gearstones and beyond, turning right when Gayle Beck comes into view. You can then follow that beck down at your leisure and view the delights of Thorns Gill.

It's probably less than half a mile long, but it is light years away from the more populated and busy areas of the Dales. The first stop on the route is Holme Hill Cave (SD785802), a former show cave that is anything but new. It is on the right-hand side of the beck and can be easily entered. Signs of its past are evident as soon as you wade in as there is an iron gate just inside the entrance. The water is pretty deep inside, but it does lead to a fine stream passage that is worth it if you don't might wet feet and legs. After a while the airspace gets a little tighter so it's best to make your way back out.

Returning back to the left-hand side of the Gayle, you follow it down to the gill, which has been formed by the beck cutting its way through the limestone. Eroded cliffs are on either side and inside are pools, pretty waterfalls and plenty of wild flowers. It's an oasis for the senses.

Further down is Katnot Cave – also known as Capnut Cave – this time on the left hand side of the gill at the base of a low cliff high above the beck (SD780797). The entrance is obvious and leads into a chamber before the floor

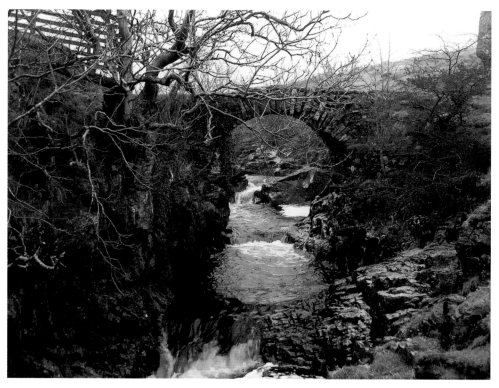

A bridge over Thorns Gill.

rises and you meet a fine-washed streamway with pools and fairly easy cascades. It also has some amazing features, colours and formations. Well worth the wet feet and, shamefully, the graffiti in the first chamber. It is possible to continue your journey further from this point, but you'll be crawling in water for nearly 200 metres before there is no way further. It's best to scramble back out and enjoy the rest of the gill.

Thorns Gill Cave lies at the end of the gill and swallows much of the water in the beck – good to view from the beck, but certainly not worth heading into – and is pretty dangerous as well. It's best to take in your surroundings and enjoy the short but magnificent ravine.

Details

Both Holme Hill and Katnot are active caves. The latter takes a fairly hefty stream in flood and should be avoided at that time. You'll also notice a number of heavy boulders inside the entrance, which are evidence of falls from the roof. You'll also get very dirty! Hopefully someday someone will find out how to remove the graffiti. Grid references are detailed above.

19 Whernside

Whernside is a complex mountain. Walk along its ridge and if you stay to the left of the wall – approaching from Blea Moor – you are in Yorkshire. Touch the trig point, which is about 2 metres from that wall, and you are in Cumbria. It's known as the roof of Yorkshire …

In any case, at 2,415 feet, Whernside is part of the Three Peaks and the one that gets most overlooked. It certainly isn't as pretty as Ingleborough and Pen-y-ghent, but its ridge walk is as good as any in the country.

The traditional route takes you past Ribblehead Viaduct and Blea Moor signal box before following the path left just before Blea Moor tunnel. Passing Forcegill Waterfall on the left, you climb up further before turning left, over the stile, to head towards the ridge. Alternatively, you can climb via Dent taking in Whernside's peaceful tarns on the way.

On descent, when you arrive at the bottom, you can turn right and take in Bruntscar and, if you have some miles in your legs, Ellerbeck and the St Leonard's church in Chapel-le-Dale.

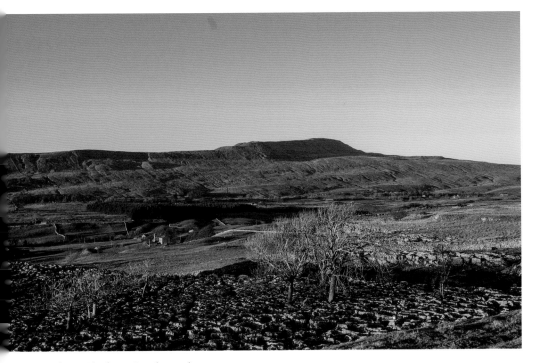

Whernside from Southerscales.

Welcoming committee ... and they weren't mooooving.

It is possible to bivvy on Whernside, as it is on all the three peaks, so you and the mountains are alone as the sun comes up. Arrive late, leave early and take everything with you. No open fires.

Details

Ribblehead station is the perfect starting point if arriving by train. Parking is available at Ribblehead too. Grid ref.: SD738814.

20 Ribblehead Viaduct

One of the most mystical places in the Yorkshire Dales is Ribblehead Viaduct, and every time you visit you get a different view of its twenty-four arches that support the weight of the historic Settle–Carlisle Railway.

The line's roots hark back to the 1860s when the East and West Coast Main Lines linked England and Scotland. The Midland Railway had to negotiate terms with

their main operating rivals if they wanted to move freight or people beyond their boundaries. That was never as successful as it should have been, so the firm looked at building a route from Settle to Carlisle to avoid the use of other companies.

After agreeing a proposed line, the company lobbied Parliament for permission, with success. But no sooner was that granted than relations with rival rail companies improved for the better. Midland asked for the decision to be reversed but that was rejected.

With no going back, construction began in 1869 and was completed in seven years with around 6,000 men working across the 73-mile route. The line was opened to passengers on 1 May 1876, with freight having been carried for the first time roughly a year previously. In 1968, the service became entirely diesel operated, but all local stations – apart from Settle and Appleby – closed in 1970. Eleven years later, recommendations were made to close the route to passengers, mainly because of the sheer cost of weatherproofing Ribblehead Viaduct. British Rail looked at keeping the route open and even spoke about creating new bridges. Eventually they relented and made the structure safe. A project manager was then appointed by British Rail to close the line, but instead he encouraged passengers to use it more and local stations reopened in 1986. Three years later, the government backed this approach.

The landscape around Ribblehead is filled with the legacy of its construction. When building began at Ribblehead in 1869, materials for the major architectural

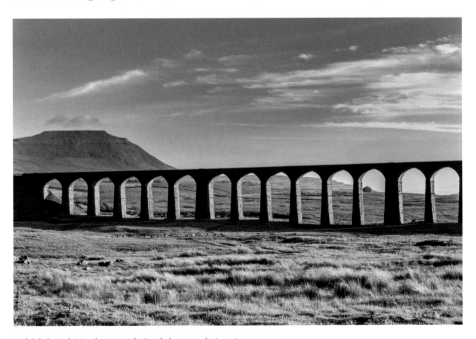

Ribblehead Viaduct with Ingleborough in view.

projects of the viaduct and Blea Moor Tunnel were manufactured locally and brought on to the site via small steam locomotives on a small tramway. The stone would be transferred from Ingleton by horse. The viaduct's foundations were sunk some 7½ metres down into the peat and clay and were laid by steam cranes.

Before you take the obvious path down to Ribblehead you can see the faint outline of the Batty Green construction camp. Here there were offices and shops – a small town of wooden shacks, which were removed when the project was completed. Near the excellent tea wagon, a little further down the road, to the right, is a grassy bit that housed a smallpox hospital.

Back on to the main path you'll approach a fork in the route and the tramway on the right. Materials would have been housed where the Station Inn is now. Behind the information panel at this junction there was a locomotive maintenance shed and an inspection pit so mechanics could get underneath the locos. The Porter & Co. of Carlisle brickworks are just a little further along the tramway, and at the height of construction around 20,000 bricks a day were being produced there.

Brick workers were housed in a shanty town on the moor called Sebastopol – named after the Crimean War siege of 1855 – with Inkerman, Jericho, Jerusalem and Belgravia nearby. The latter gave a great view over the entire project and was sited where the tramway begins a significant turn to the left. Figures seem to suggest that there were 150 huts between Batty Moss and Dent Head and, according to the census in 1871, had more than 1,000 men, women and children living in them – a number of whom sadly died during the construction due to accidents and smallpox.

Details

Ribblehead Viaduct is unmissable as you travel on the B6255 from Ingleton to Hawes. It is easily accessible and has a parking lay-by. Trains stop at Ribblehead station and the Station Inn is a cracker of a pub! There are several caves on the site too that can be explored with extreme care.

21 Bruntscar Cave

We have all been stretched out on our favourite chair when we hear the drip drip of a tap or a strange sound that has us craning our necks to find out where it is coming from. More often than not, curiosity gets the better of us and we get our

heads under sinks, in lofts and outside with ears to drains to find out what the problem is.

Back in 1865 a curious rumbling got the better of Bruntscar Hall owner Mr F. Kidd. He was often on his estate and heard a fairly large noise below his house. Armed with hammers, picks and sheer brute strength, he uncovered the source of the noise – the entrance to a superb cave, right up against his barn.

Today, that barn may be a shadow of what it was, but the cave can be explored, in good weather, by people with the same sense of adventure and who aren't afraid to get a bit wet. Asking at the Bruntscar Hall for permission to enter – and afterwards placing a donation into the church box at St Leonard's – you go around to the barn, don wellies and drop down to the entrance. Inside is a gate that shows Mr Kidd probably wanted to open Bruntscar as a show cave. The entrance has been clearly blasted and the floor levelled. Indeed, local writing seems to indicate that Mr Kidd wanted to make significant improvements and possibly turn the stream on or off. No such luck on my visit!

The cave is around 850 metres long in total – but that

Hidden behind a barn ...

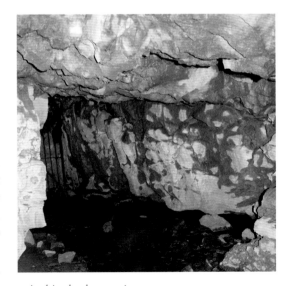

... is this cheeky cave!

belongs to the realm of cavers who don't mind flat out crawls. Inside, there are fantastic flowstone features, stalactites and other sights that beg to be viewed. A classic teardrop-shaped passage takes you to a hands-and-knees crawl in a pool before you come to a waterfall chamber. Not easy to climb but worth it, you soon meet another two waterfalls and flowstone blockages that again force you to crawl. The main stream is also met – and it certainly awakens the senses with its sheer noise – but that is tempered by the wonderful features that lie beyond.

Details

Bruntscar can be visited when the weather is settled and you are properly equipped. The cave is on private land and therefore permission must be sought from the farm and a donation made to St Leonard's church before entry is made. These details are important to ensure people have access to this gem for years to come. It is reached by taking Philpin Lane on the opposite side of the road to the Hill Inn and turning left at the junction at Whernside. The hall is recognised by its 1689 datestone. Grid ref.: SD738789.

22 St Leonard's Church

Sited on an old Roman route across the moors it's not hard to imagine that wayfarers used this beautiful Dale spot to muse upon life and catch their breath before their journey continued. Today, it may be a site of worship but it is still used in the same way. The visitors' book is filled with people walking past St Leonard's and taking their ease before they walk on.

It's not exactly known when a place of worship was founded here, but the land on which it is sited was owned by the monks of Furness Abbey in the fourteenth and fifteenth centuries. Back then, the Dale was known as Weyesdale and it is assumed that a small chapel would more than likely have been built. If so, it was a chapel of ease, spiritually attached to Low Bentham back towards Lancaster – a place which would have been too far to travel for locals around the area. In 1595, it was recorded as the 'Chapel of Wyersdaile' in a Chester Diocesan document. Some twenty-three years later it was the 'Chapel of Witfalls' and some sixty years after that the 'Chapel 'ith Dale', although the latter is more

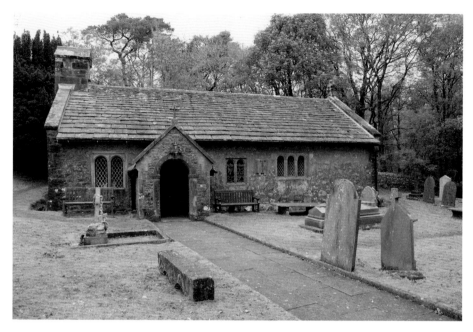

St Leonard's church – a place of ease and reflection.

likely to be a colloquialism. It seems from there it was commonly known as Ingleton Fells Chapel.

St Leonard is, ironically, the patron saint of prisoners. It's suggested that a local historian found an old will referring to it by that name, but subsequent research said that was connected to a chapel in Ingleton. Either way it stuck, despite not being officially dedicated. It was renovated in 1869 – the same time it became a parish in its own right – and that was handy in a sad way as the number of fatalities from the railway construction camps at Blea Moor and Ribblehead was about to increase significantly. In 1870, a smallpox epidemic took the souls of a large number of navvies and their families and in the end more than 200 were buried here – so much so that the land around St Leonard's had to be expanded. In Turner's painting you can see trees nearby to the church, but these had to be removed in order to enlarge the graveyard. The Reverend Ebenezer Smith worked closely with the Midland Railway's missionary worker James Tiplady to care for the families on the railways and to bury those who perished in the east side of the churchyard – most in unmarked graves.

The burial records for this time make startling and sober reading. A six-year-old girl called Annie Wall was buried on 5 August 1870 after being involved in an accident. Six months later a nineteen-month-old baby died at Blea Moor. From May 1870 and twelve months on, more than forty were buried

there and the green mounds that signalled burials in the churchyard were more apparent. As stated previously, this meant the yard was expanded and the Revd Smith even paid for Yew trees to be planted in the western side to make it more peaceful and tranquil as a resting place. In 1871, in just two weeks, the Fassam family lost five members to smallpox. The girls were eight months, two, five and six years old with their mother, Hannah, dying at just thirty-three. It is fitting that there is a plaque in the church to commemorate the men who died, and in 2000, a simple stone monument was raised to cherish the memory of those wives and children.

Details

Take the B6255 from Ingleton and Chapel-le-Dale is signposted around 2 miles after White Scar Caves. If you are travelling from Hawes then the church is a mile from the Hill Inn. Cars can park at the church's car park, but you must leave space for locals and make a decent donation in the church itself.

23 Ingleborough

There probably isn't a more iconic summit in the whole of the Yorkshire Dales than Ingleborough, and it can be enjoyed in a number of ways ... above and below ground.

Its horizontal plateau and layered look is revered all over the world. It's easily spotted from the distance and attracts far more people than its Whernside and Pen-y-ghent cousins. At 2,372 feet high, it is capped by millstone grit that is probably more than 320 million years old. It was formed when coarse sand mixed with quartz and crystals and washed downstream from the granite mountains in the north by strong tropical storms. At around the same time, limestone was beginning to form in the region at the bottom of a shallow tropical sea. Shells and the right chemical balance caused the carboniferous matter to compact and rest and later become a significant part of what the area is all about.

Over time, the tropical sea disappeared and subsequent ice ages saw glaciers from Scandinavia, Scotland, the Lakes and Pennines merge to flow south and scour the limestone and leave three distinctive peaks capped with that famous gritstone.

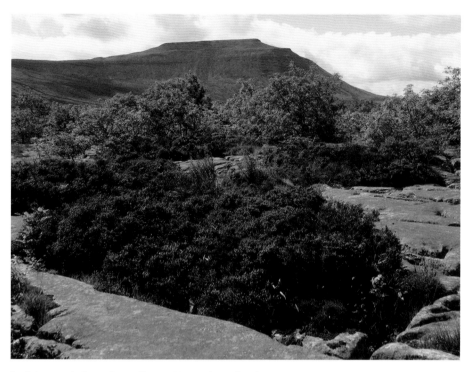

Ingleborough from Scar Close. (Natural England)

The limestone pavement formed when glaciers washed away soil, debris and weaker rocks. Metres of milky white rock emerged from the glacier and then were subject to rainwater, which seeped into fissures known as grykes. The powerful ice flow took limestone from the edge of stronger beds to create long lines of scars too.

It is thought that three ice ages shaped the Dales into what it is today. Glaciers swept across massifs and each limestone pavement was eliminated by the advance of the next flow. It formed glacial troughs and blocked up the caves that had been forming over many years until the meltwater opened them up once more.

Ingleborough in particular had a significant flow of ice around it, and the pavements of Sulber and Southerscales were created as the ice scarred and marked the limestone. To the south and west the ice flow had less energy so it dumped tonnes of boulder clay.

The hill has a pull you cannot fail to heed. From its summit, on a clear day, you can see well into the Lakeland Fells. It housed an Iron Age fort, which was probably built in the first century AD by the Brigantes as they looked to defend the area against the Romans. Archaeological digs have shown there was a stone 'rampart' made out of the grit and there were foundations of circular stone huts

too. Some people have suggested that these could even be Bronze Age in origin and there is a theory that as the rampart takes several separate forms it might not have been a defensive structure after all.

Ingleborough has several routes to the top and that makes it popular. However, it is possible to have the hill to yourself at the right time. Walk up from Clapham at sunrise and you won't meet anyone until you return. The route up from the Hill Inn is long and therefore quiet too – and it passes near Southerscales, a wonderful limestone pavement that has to be viewed. Reversing the traditional Three Peaks route and climbing up from Horton first is another route seldom used. A late-night bivvy on a cloud-free night is something to experience.

Below ground Ingleborough offers some of the finest caving around. Gaping Gill, Alum Pot, The Allotment and White Scar are all in its shadow.

The complete gem.

Details

Ingleborough dominates the landscape of the three peaks and can be accessed from many different directions. Popular routes begin from Ingleton and Chapel-le-Dale and you won't go far wrong with either. Personally, the route from Clapham is my gem, passing the nature trail and Gaping Gill on the way up. The summit is often covered in mist so please take a map and compass and know how to use them. Grid ref.: SD740745.

24 Ingleton

For many walkers and cavers heading to the Dales, Ingleton is the base for exploration.

Being at the foot of Ingleborough, having varied and striking limestone features (known as karst) all around plus waterfalls, glens and memorable walks as well as great shops and an open-air swimming pool, could you ask for much more?

Ingleton has always been a destination of mine whenever I am in the Dales. It's a regular pilgrimage that comes from my younger days, in which a trip up the M6 could have brought a good look around the caving shops and the possibility of going underground. For that alone, caving cafés Inglesport (best flapjack in the world) and Bernie's are must visits.

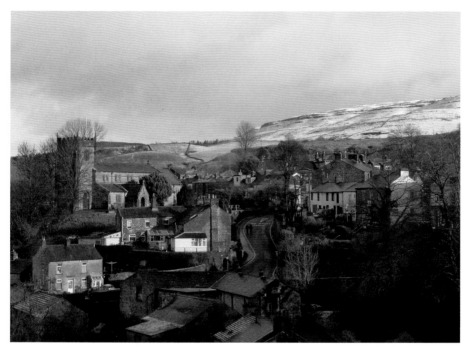

Ingleton in winter. (Johnny Hartnell)

Ingleton was settled in the Iron Age by the Brigantes who, it is thought, built a hill fort on Ingleborough as they looked to defend the area against the Romans.

The Romans defeated them eventually and built their own fort at the site. The valley was crossed by Roman roads as the village was seen as a strategic river crossing.

The church of St Mary dates from the late nineteenth century but has a Norman font that is more than 850 years old. There are also a number of sixteenth-century buildings in the village, and an old bullring, where animals were baited and slaughtered, is still visible in the tarmac.

Interestingly, there is a suggestion that Sir Arthur Conan Doyle got the name for his most famous detective from the village. His mother Mary lived in Masongill, a hamlet nearby, and there's no doubt he would have been a frequent visitor to the area. Add to that the fact that the viaduct that crosses the valley in the village is called the 'Holmes', then the evidence is stronger ... or is it just a coincidence? Elementary.

Details
Ingleton is just off the A65 between Skipton and Kendal.

25 Thornton Force

Part of the Ingleton Waterfalls Walk, there is nothing more dramatic than Thornton Force in flood – and like most of the falls it is best viewed after it has been raining.

Of course that might not be the best conditions to enjoy a walk, but sogginess is a small price to pay for the quality of this 4-mile wander set within a Site of Special Scientific Interest.

Park at the falls' car park in Ingleton and take the obvious path through the Swilla Glen, past Pecca Falls and Hollybush Spout until you begin to climb. Thornton Force is just under halfway around the walk and more than obvious. The River Twiss plunges nearly 50 feet over a cliff of limestone – left exposed by the retreat of a glacier – that is more than 330 million years old.

If you get close to the waterfall itself, you can see the many layers of strata

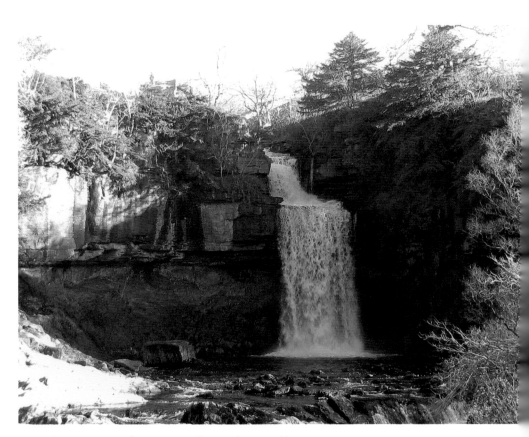

The River Twiss flows over millions of years of history.

that have made the area a magnet for geologists and school field trips. In one span of your hand you have millions of years of history. Mind-boggling.

Details

It is possible to visit Thornton Force (Grid ref.: SD 694 753) without taking in the whole of the waterfalls walk, but that would be plain daft with the natural wonders on show! The trail, sited in Ingleton and well signposted, is open every day apart from Christmas Day. There is an entry cost of £14 for families, £6 for adults and £3 for children under sixteen.

26 Ingleton Waterfalls

While Thornton Force is the obvious jewel in the crown of the Ingleton Waterfall Trail as the River Twiss continues its route from the North Craven Fault to the South Craven Fault, it would be remiss not to celebrate the other gems of the walk. Why? Because they are as stunning as the geology that created them – something that surrounds you as you complete the 4-mile circular.

The Waterfall Walk opened on Good Friday in 1885 and retains much of the old route that is partly on private land. You begin by following the River Twiss through Swilla Glen, which is cut into carboniferous limestone – evident especially on the left-hand side – exposing the more durable rock underneath. Here, and on the return route at the quarry, you pass the South Craven Fault and the limestone cap is revealed in cliffs probably exceeding 200 feet. Wild plants and trees like birch and hazel are abundant but as you continue your walk that quickly shifts to bracken and heather, which thrives on acidic soil.

Pecca Falls come into view and again are best viewed in rain. There are five waterfalls that flow over sandstone and slate before the walk continues upwards to Hollybush Spout. From there, Thornton Force comes into view, and then there is a steep walk up to a Roman road called Twistleton Lane. From there, the trail picks up the River Doe and the spectacular Beezley Falls – three waterfalls side by side. Rival Falls and Baxengyhll Gorge follow – the viewing platform gives a spectacular view of the river well below and the serene Snow Falls.

Twistleton Glen then follows with the river a fair way away from you on the

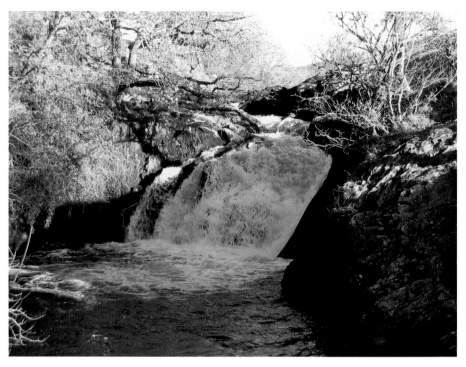

Beezley Falls on the Ingleton Waterfalls Trail.

right. The route also takes you through Ingleton's industrial past, with quarries and kilns, before you emerge in the village itself. A quality walk.

Details
The trail, sited in Ingleton and well signposted, is open every day except Christmas Day. There is an entry cost of £14 for families, £6 for adults and £3 for children under sixteen.

27 Cheese Press Stone

Karst scenery by its very nature can be very varied. From the sweeping scars of Twistleton, White Scar and Southerscales to the Norber Erratics near

Austwick and the caves and potholes at Ease Gill, it can be very haphazard and dynamic.

Taking the path to the Turbary Road, this scenery is among the finest. You climb into an area of dense limestone, boulders and pavement, before reaching a fairly flat area with Gragareth stretching ahead. Here, in this superb karst, are the Cheese Press Stones.

I'd been in this area too many times to mention and just took the stones for granted. They were marked on the map, and Alfred Wainwright noted them in his book *Walks in Limestone Country*. However, I was far more interested in the Turbary Road itself and Kingsdale with its flat valley floor and steep limestone scars either side, one of which I was climbing, the dale itself the almost perfect definition of glaciation and its results.

Indeed, Kingsdale is a gem in itself. It is probably 3 miles in length before it finishes and encloses itself in glacial drift. Its caves – Rowten Pot, Swinsto and Simpsons on the left, all of which link to Kingsdale Master Cave and Valley Entrance, and Heron Pot, King Pot and its cousins on the right – are legendary in caving circles the world over. And even then, Kingsdale Beck is dry in most conditions until it meets Keld Head – the resurgence for those subterranean journeys.

Yet, approaching them with Tow Scar (SD684760) on my left, I wondered

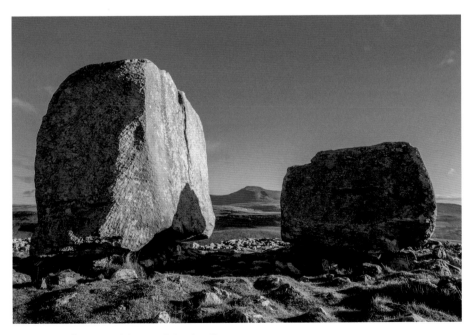

The stones frame Ingleborough in the distance.

where they had been all my life. Two stones, almost laid on a plate, with Ingleborough and the Dales stretching behind them. The perfect photograph.

The stones – one large, perhaps 9 or 10 foot in height, and one smaller by about 2 feet – were more than likely left stranded in this location by ice movement in the Ice Age. Since then, unlike the limestone which is nearby, they have been shaped and smoothed by the elements, not contorted or cracked.

Spend an hour exploring them, lie flat on the ground with a backpack for a pillow and just take in the noise, smells, openness and exposure.

Details

There isn't an easy way to get to the Cheese Press Stone other than under your own steam! Follow the road to Thornton in Lonsdale (signposted near and from Ingleton), and when you reach the Marton Arms take Thornton Lane on the right. From there, take the lane upwards until the landscape opens out. On your left will be a radio tower, but don't take the road past it, continue onwards for a couple of hundred yards and there will be a lay-by on your left. If you have gone past the obvious parking point on your right after the road dips and the lane that stretches back towards the waterfalls walk, you have gone too far. Take the path over the stile to the Turbary Road, which will take you over a wall and then into an area of limestone boulders, pavement and other scenery. The Cheese Press Stone is at SD688761.

28 Yordas Cave

My wellies dangled over a hole much less than a metre in width. Below was a sheer drop of around 80 feet and the only thing stopping me from falling was my caving kit and, for a few moments, the pounding of my heart in my chest. Inching forward I had to counteract not only the fact that I was nervous, but that I was trusting a single rope around a centimetre in diameter to keep me from a very quick descent indeed. Pushing off, the tackle bag on my back inched slowly down the limestone before it released itself, back into its rightful position. Below me I couldn't see the floor, but I could hear the drip of water from behind me, and I could see the polished walls all around me. I was in Yordas Pot, some 79 feet away from the bottom, and making my way to Yordas Cave, a former show cave.

Yordas, which comes from the Nordic to mean 'earth stream', was opened as a show cave in the early 1800s, although it does have an inscription inside from 1653. After walking down the steps, the Great Hall measures 55 metres by 15 metres and to the left it is possible to follow the stream into a low crawl. On the right, towards the far end, is the Bishop's Throne and wonderful Chapter House waterfall (around 30 feet tall), which would be my exit from the vast chamber.

The low crawl from Yordas Pot.

Back in the Yordas Pot, which is further up Yordas Wood (SD705791), I was making my way down the rope watching water fall down the walls before I reached the bottom. Johnny Hartnell, my guide, leader and friend, came down next before we unhooked ourselves from the rope and made our way out of the pot through a small portal, meeting the stream as it made its way to Yordas Cave. The crawl is flat out at first, in water, a bedding crawl before it enlarges slowly to stooping height. Midway is a route on the left to Yordas's two middle entrances. Back in the streamway the roof breaks now and again to reveal a glistening ceiling and sharp edges cut by powerful torrents of water. Eventually, we reached the Chapter House waterfall. I'd seen this many times from

The entrance to Yordas Cave. (Stephen Oldfield)

Formations on the way to the Chapter House.

the cave itself, below, watching in awe at the power of the falls. In very wet conditions, cavers have to traverse out a little at the top to gain a more direct route to the floor (30 feet), but even though it was wet Johnny opted for the more traditional route.

Buoyed by the success of the first pitch, the second one, I thought, would be a doddle. I pushed off with my legs and went straight into the water. Next push did the same, and again, ice-cold water entering my ears and the top of my caving suit. I wouldn't have wanted it any other way. At the bottom, a pitch that seemed to take forever, I prodded around in the Chapter House and made my way out into the chamber itself. We looked at the Map of Wales and other features and then made our way down to the crawl for a look at a couple of digs that have taken place and are still proceeding in the chamber.

Making our way out of the show cave entrance (pictured in daylight), the night was cool, crisp and clear. The moon illuminated our route back up to the pot and the retrieval of equipment. It was a truly breath-taking evening.

Details

Not everyone can progress the route I did above, but Yordas Cave is easily accessible for those who don't mind wet feet and have a very good torch. Take the road to Thornton in Lonsdale and turn right at the Marton Arms. Head along this road until you see a wood on your left. Yordas is in here and there is lay-by parking. Grid ref.: SD705791.

29 White Scar Show Cave

Set in the shadow of Ingleborough, White Scar Cave is a true gem in an area of outstanding natural beauty. Many people will take the route past the entrance, along the B6255, and see sometimes hundreds of cars parked up waiting for their tour. Those that don't like places where it is too busy will shun it and miss out on what is a staggeringly beautiful trip.

For its sheer size and entrance, it's a surprise that it wasn't found until August 1923, but of course the entrance now is somewhat different from when it was discovered.

Cambridge student Christopher Long was on a holiday in the Dales and,

after pausing on a walk, noticed a slight gap in the ground. Putting his head in, he heard the roar of water. No doubt with heart racing, and no concern for his safety, he crawled over rocks and through pools until he came to the foot of a waterfall – all with just candles stuck into his hat to illuminate his way.

Several other trips into the system saw Long swimming across lakes, squeezing past a massive boulder now known as Big Bertha – the size of a double-decker bus – before he could go on no further.

It was pretty obvious what a commercial opportunity this trip was, and he made plans to open it as a show cave. However, before his dream could be realised, he died of an overdose of a type of

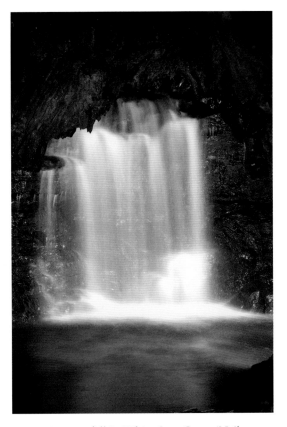

Fantastic waterfall in White Scar Cave. (Neil Jinkerson)

anaesthetic. Lieutenant Colonel Geoffrey Smith took up Long's work, blasted a tunnel and installed lights and flooring up to the second waterfall. It opened on 10 April 1925.

In the '70s, the Happy Wanderers caving club managed to navigate the boulder and squeeze up into a massive cavern called the Battlefield Cavern. It was Hilda Guthrie who had the honour of entering the boulder-strewn cavern for the first time and witnessing its staggering stalactites and other features.

Now, a tunnel connects the show cave to this cavern ... and it's well worth the stair climb up, so much so that a couple have used Battlefield Cavern as the staging post for their wedding.

The cave is somewhat different to the likes of Ingleborough and Stump Cross. You can see from the entrance that it has the visitor in mind. It has an excellent café too, but that is the only touristy thing about it. The cave itself is amazing and well worth the admission fee. In fact, the first waterfall is worth the charge alone.

Details

The best way to visit White Scar is to drive or walk up from Ingleton. It is well signposted. Admission is £9.50 for adults, £6 for children and £26 for a family ticket. For opening times and other details visit www.whitescarcave.co.uk. Grid ref.: SD712745.

30 Clapham

Many villages in the Dales, particularly around the border of the national park, badge themselves as windows to explore this fantastic area of the country. Skipton is the 'Gateway to the Dales' and Clapham is the 'Doorway'. Never has a description been more apt.

Built around Clapham Beck, the village is a bustling epicentre for people exploring the Dales but never gets away from the fact that it is home to hundreds of local people. In fact, social policies, in the past anyway, from the Farrer family, the owners of the Ingleborough Estate, have ensured local families have had the opportunity to live in the village for affordable rents.

The village itself, like most sites in the area, suffered from Scottish raids in the fourteenth century. They saw the damage of the church of St James, and while the medieval tower remains from that period, most of the building work there harks back to the nineteenth century. It is at the head of the village, with the wonderful New Inn at the other end. In between, on the right-hand side of the beck if you are looking at it from the inn, are a number of tea rooms, shops and the Cave Rescue Headquarters. The latter emergency service does sterling work above and below ground and accepts donations at their headquarters.

The reason that Cave Rescue is based in the village is pretty obvious when you consider that just a few miles or so from its centre is the Gaping Gill system, one of the world's premier caving areas. However, more rescues are now completed above ground as the caving pool becomes more experienced and the number of participants decreases.

Probably the most important part of village life is the contribution of the Farrer family, whose Ingleborough Estate was established in the eighteenth century. They are responsible for most of the beauty in the area including the

Clapham is a quaint, tranquil village.

woods, fields, moors and farms of the village. Reginald Farrer established the nature trail, which is detailed elsewhere in this book.

Dr John Farrer passed away in 2014 at the age of ninety-three, and up until the time of his death, he was active in managing the estate. Australian by birth, he came to the area in 1953 when he learned of his uncle Roland Farrer's death. That saw him charged with the task of taking over the estate that had been in the family for hundreds of years. He transformed the finances of the estate and did much of the handiwork on it himself as well as continuing to practice as a doctor until he was seventy. Throughout his tenure he had a policy of affordable rents with a preference given to young families. He was a governor of Clapham School for more than fifty years, supported Cave Rescue, administered permits to visit caves on the estate and was warden at the church. He was a remarkable man in a remarkable village.

Details

Clapham is the perfect base to climb Ingleborough – as long as you enjoy the local amenities and park in the national park's car park before or afterwards! It is assessable from the A65, around 6 miles from Settle and 3 from Ingleton. Clapham station is close by.

31 Ingleborough Nature Trail

Reginald Farrer was a botanist, who, from his birth in 1880 to his untimely death forty years later, loved landscape, exotic plants and travel.

He resided in Clapham, and would plant the seeds and botanical species that he had collected on his travels in the family's grounds in the village. He had a particular fondness of Alpines, shrubs and other plants that he would find in China, Tibet and Burma. They would be brought back to England, arranged and planted, and, remarkably, they survived because the soil was acidic. He was meticulous, knowledgeable and ingenious. Worried that the plants might not grow as they should or replicate the ones from his travels, he would load seeds into a shotgun and fire them into the cliffs.

You can see those plants today courtesy of Ingleborough Nature Trail, which

The lake on the Ingleborough Nature Trail.

was established in 1970 to celebrate Reginald's life and contribution to the village and to mark European Conservation Year. For a nominal charge you can saunter along a superb and non-arduous trail taking in a glass-like lake, Himalayan Rhododendron, bamboo and other unusual plants you wouldn't normally find in Yorkshire.

The lake may be artificial but it sets the walk off beautifully, and early in the morning the mist hovers above it to be almost ghost like. It provided power to street lights hydroelectrically and Clapham was one of the first villages in the UK to have such illumination ... and one of the last to be on the 'official' grid. The lake also helps provide Clapham with some of its water needs.

Probably the most iconic part of the route, apart from the wonderful glacial valley which takes you through Clapdale Wood and onwards to Ingleborough Cave, Trow Gill and Gaping Gill, is the grotto which was built as shelter. It was commissioned by the Farrer family to provide work in the early nineteenth century because of recession.

It gives a great view of the limestone cliffs beyond and is a great place to stop and ponder the fantastic work of Reginald and the Farrers.

Details

Park in the national park's car park and then turn right out of the entrance, past the church and then right again to the start of the trail. There is a small charge, payable via machine.

32 Ingleborough Cave

The moment you emerge from the Ingleborough nature trail into the clearing near Ingleborough Cave is pretty surreal.

The walk is so full of the wonders Reginald Farrer brought back from his travels, that to come out and see a small babbling brook on the right and the short cropped and somewhat barren landscape can be a little strange.

When your senses adjust, it is an amazingly peaceful place to be, as all you can hear is the water and an ever so slight knocking in the distance. About 180 metres up, you find out where that knocking is coming from – a hydram pump which uses 98 per cent of water energy to pump water 100 metres up the path.

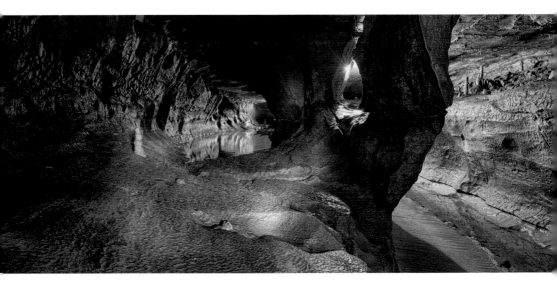

Some of the fine formations in Ingleborough Cave. (Bob Jarman)

After another 68 metres or so, you arrive at Ingleborough Cave, one of the finest show caves in the country and 'leased' from Ingleborough Estate by Bob Jarman.

It is part of the Gaping Gill system, although there isn't a dry link between the two as Fell Beck makes its way to the show cave via submerged passages. It was discovered in 1837 and the part you can visit is around a kilometre long. Bob took over the cave in 1960 and still makes the daily trip to the site to conduct tours and run a small shop there.

Originally, the cave was run by Ingleborough Estate. Bob would come up to the area with some friends from Bradford and do some caving. It was looked after by a retired estate worker and it eventually got a little too much for him. He decided he was going to retire so Bob, worried about the sanctity of his weekends away, asked if he and his two caving colleagues could take it over … and they did.

The cave was opened to the public when local landowner James Farrer realised that large passages had to exist behind calcite barriers after a severe flood. He had them broken to release the water and discovered the extensive passages that lay beyond – and the public are better off for it. The walls glisten if the temperature is just right, there are hidden passages and features such as the Sword of Damocles, the Bee Hive and crystal pools.

At the end of the tourist path, the out of bounds passage continues by climbing upwards and narrowing until it eventually connects with Gaping Gill. The link between the two was made in 1983 by the Bradford Pothole Club and

Cave Diving Group. All in all, the passages in Ingleborough Cave stretch more than 4 kilometres.

Details

The best (and probably only) way to visit Ingleborough Cave is from Clapham. Walk through the Ingleborough nature trail and you will find the cave is on the left as you come out of Clapdale Wood. Entry costs £8 for adults, £4 for children of school age and free for younger children, and £6 for students and senior citizens. A family ticket is £20. Visit www.ingleboroughcave.co.uk for more information. Grid ref.: SD754710.

33 Trow Gill

Just up the path from Ingleborough Cave is the limestone ravine of Trow Gill. Much like Gordale Scar, but certainly not in terms of size, its wonder comes up on you suddenly.

It was formed when the meltwater that couldn't sink into Gaping Gill cut through the limestone to create a gorge. The ground was frozen solid and that meant the water could move more quickly as it flowed on to Clapham Bottoms.

The path takes you through a boulder-floored slot at the top where recesses indicate the position of deep potholes formed by swirling water, which effectively then enlarged to form Trow Gill.

Just before Trow Gill itself, as the path sweeps left, are Foxholes. These are three caves that have revealed Neolithic material. They are gated now to block access but are worth seeing.

Interestingly, Trow Gill was the scene of a controversy just after the Second World War when a skeleton was found in the then unnamed Body Pot some 800 metres away. Two cavers found a body – subsequently named the Trow Gill Skeleton – on 24 August 1947, with a post mortem revealing he was 5 feet, 5 inches tall, aged between twenty-two and thirty at the time of death, and that his passing had occurred at least two to six years previous. He had been wearing a blue shirt, tie and a grey-blue suit with red and white stripes, a herringbone overcoat, trilby hat and a plum-coloured scarf. He had a bottle of sodium cyanide on him and an unbroken ampoule of the same material,

Trow Gill is stunning as you approach.

mineral water, a watch and other personal items, including a pen, pencil and compass.

A local historian claimed users of such ampoules were spies, and therefore the connection between the body and him as a possible German spy came forward – something denied by German documents after the war.

The inquest returned a verdict of insufficient evidence as to the cause of death … but it's up to you what you believe!

Details

Trow Gill (SD754717) is best approached from Clapham and the nature trail at the top end of the village. It costs a few pence to enter and is well worth the walk. The gill can be found past Ingleborough Cave. If Body Pot tickles your fancy then the grid reference is SD758724.

34 Gaping Gill

There probably isn't a more well known and iconic pothole in the world than Gaping Gill.

Impressive above and below ground, in the shadow of Ingleborough, Fell Beck meanders along the hillside until it plunges 365 feet into an open chasm.

This pothole was first bottomed in 1895 after a number of previous attempts inched closer to its floor. John Birkbeck reached a ledge around 58 metres down in 1842, and that bears his name today. But it was the much travelled and revered French caver Édouard-Alfred Martel who finally hit the bottom in 1895, and subsequent explorations have found more than 11 kilometres of passage and the link to Ingleborough Cave down the valley.

There are a number of ways into the system, all out of bounds to non-cavers. In fact, those having a look around the large surface entrance to Gaping Gill could easily find their way to the bottom via one slip at the various routes (Rat Hole, Dihedral Route) down the shaft. These can be found without you knowing so it's best to stay to one side and watch the beck make its route down the pothole. In flood, it is awe-inspiring and a positively frightful sight. One side route in particular, the Rat Hole, looks fairly innocuous, but after a crawl, holes in the floor go right to the bottom. Best left alone.

Around the gill are other entrances including Disappointment Pot and Flood Entrance and the more obvious Bar Pot, which is just over the stile as you head towards Gaping Gill from Trow Gill. The surface entrances, apart from the Gaping Gill itself, are probably not

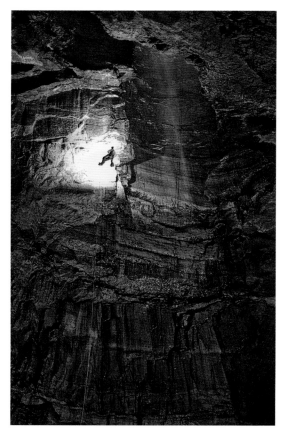

Looking up at a caver coming down the main shaft in Gaping Gill. (Andy Jackson)

as picturesque as, say, the ones at Ease Gill, but the wonder at what is happening underneath your feet is just as exciting.

For those who aren't experienced cavers, there is the opportunity to be winched down the shaft courtesy of the Craven Pothole Club and Bradford Pothole Club. These meets occur on the spring and summer bank holidays and are well worth it. To be inside Gaping Gill and looking up – it's a well-known statistic that St Paul's Cathedral could fit inside – is something else. The adage is that you aren't charged for the descent, but for the ascent afterwards, and although you will get soaking wet, the main beck flow is diverted on the surface via Rat Hole and other slots and crannies.

Details

The Bradford Pothole Club (www.bpc-cave.org.uk) hosts its meet around the Whitsun May bank holiday weekend, while the Craven Pothole Club (www. cravenpotholeclub.org) meet centres around the August bank holiday.

Getting to Gaping Gill is best via Clapham. Walk up through the nature trail and past Ingleborough Cave. From there climb Trow Gill and follow the well-worn path to a stile. Turn left, go past Bar Pot and take the right path when it splits to go up Ingleborough to Gaping Gill. Grid ref.: SD751727.

35 Alum Pot and The Churns

Sometimes a trip above the surface is just enough to stir the imagination instead of venturing below ground. At Ease Gill you can walk from Top Sink all the way down to the Ease Gill Kirk, popping your head in the various nooks and crannies that lie on the route.

The Alum Pot system is very similar. You can follow Long Churn Spring, which begins life on Park Fell, as it charts its route down to the large open pothole before it emerges inside the 200-foot crater.

For the more adventurous, there's the possibility of walking into the middle entrance at Upper Long Churn and making your way up to a large plunge pool called Dr Banister's Hand Basin – caused by a waterfall that is around 15 foot. At its base you can see a glint of light above. It is a simple trip, exploring the darker side of the Yorkshire Dales.

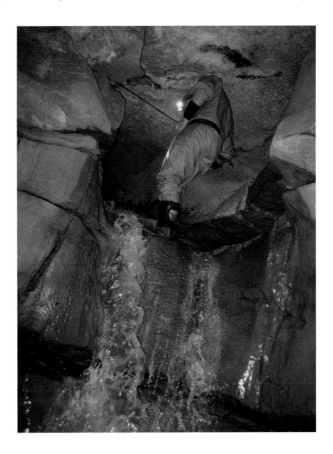

Climbing up a waterfall
in Upper Long Churn.
(Stephen Oldfield)

Lower Long Churn, which is next to the middle entrance, eventually emerges down in Alum Pot down a pitch called the Dolly Tubs.

Further up and on the right of The Churns is Wilson's Cave, which is best explored from the 'top', working your way down the canyon-style streamway with coral fossils in the floor.

On the return back to your car, if you look to the other side of the valley towards Birkwith you can see a small lake. The water from the bottom of Alum Pot has been dye tested and it emerges in there, but there is no passable underwater connection on this lengthy journey.

Details

Alum Pot is best approached from the B6255 as you leave Horton in Ribblesdale. As you pass through Selside and climb the hill, there is a track on the left. It is wide enough for a number of cars. Park here and then make your way up the obvious path – popping in at Selside Farm to pay your entrance fee – to the chasm of Alum Pot. Grid ref.: SD775756.

36 Pen-y-Ghent

From the Cumbrian 'Hill on the Border' or the Welsh 'Head of the Winds', Pen-y-ghent's strange name certainly has some interesting interpretations and both can be applied as true.

Approaching Horton on the B6479 the 2,273-foot hill cannot be avoided, nor can its distinctive shape. It is predominately carboniferous limestone and millstone grit. The latter, at the top, rests upon the former, and then there is more limestone, sandstone and shale of the Yoredale bed as it is known. Great Scar limestone follows and then slate. If you approach from the west then you can see the 'pinnacles' or rakes, which were formed by a thunderstorm in July 1881 – according to local sources. Soil was washed down to a significant depth exposing these fine features, and as a result they are popular with climbers.

Pen-y-ghent is a rite of passage for those who walk in the Dales. It is a must do and, like its three-peak cousins, offers exceptional views on a clear day. It is often overlooked as an obstacle by those who are completing the Three Peaks Challenge in twelve hours and who need to get over the hill in just over an hour if they are to realistically finish the over twenty-five-mile course in that time.

Those walks often start early in the morning, and Horton is rammed, especially at the weekends, from spring to autumn. That shouldn't turn you off what is a fantastic walk, though. Personally, I prefer to walk up the lane around the back of the Crown Pub towards Sell Gill Holes, turning right on the new Whitber Path to the crossroads at the base of the hill. There, head left to the

The view from the summit of Pen-y-ghent.

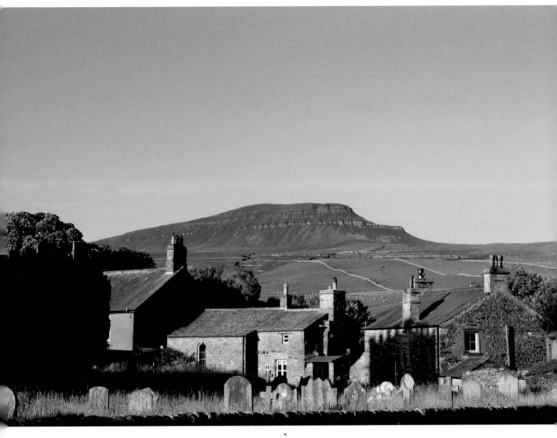

Pen-y-ghent from Horton-in-Ribblesdale.

superb Hull Pot chasm (SD824746) before returning and climbing up Pen-y-ghent via Hunt Pot.

At the top you can see views all the way out to Morecambe Bay and Ingleborough. It is best enjoyed as the sun goes down or, if you're resolute enough, in moonlight.

Details

The traditional route to Pen-y-ghent is from Horton to Brackenbottom and up to the base of the hill. During winter, this is followed by a difficult scramble up its side. Other routes include a fine yomp from Foxup, which takes in Plover Hill. If parking in Horton, please use the national park's car park. Grid ref.: SD838733.

37 Langcliffe

Langcliffe is a beautiful village just a couple of miles north of Settle on the road to Horton-in-Ribblehead.

Like many picturesque places, it seems to have evolved around its magnificent-looking church and green. But the truth lies more in the industry in the area – something that is depicted in its buildings.

It has a number of seventeenth-century buildings, including a hall built in 1602 and a stone of a naked woman, which was on an earlier house on the site. On it is carved 'LSMS', which refers to Lawrence Swainson, a woollen weaver, and his wife Margaret. Their son, who knew 'arithmetic, geometry and astronomy', is commended in Giggleswick church.

The village was owned by the Sawley Abbey but after the Dissolution of the Monasteries in 1536 was bought by the Darcy family and then sold to its tenants in 1591. Towards the nineteenth and twentieth centuries, kilns were king until 1930, corn mills were sited on the River Ribble and the school, built in 1825,

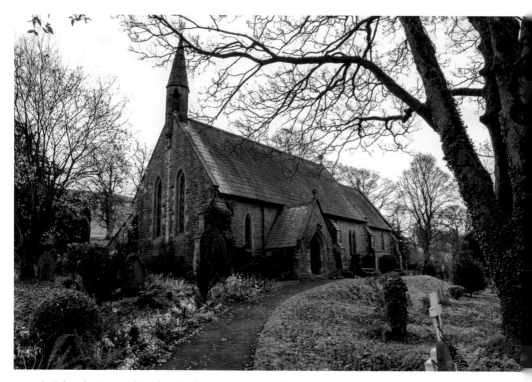

St John the Evangelist church dominates Langcliffe.

had 200 pupils in 1880. Ironically, it closed in 2007 because of a lack of pupils – a change of societal make-up felt in many rural villages in the country.

Sitting on a bench on the green, in front of you is the magnificent St John the Evangelist church, built in 1851 by architects Mallinson & Healey of Bradford. It stretches the length of the green and is unmissable. To your left lies the road up to Winskill and Malham beyond, and there are some fantastic cottages to your right. Being set off the main road, it's quiet and peaceful too.

Details

Langcliffe is just off the main road from Settle to Horton (B6479) and can be visited on the way up Winskill to Malham. It has no amenities, but that doesn't distract from the sheer elegance of the village.

38 Hoffmann Kiln

The Yorkshire Dales National Park is a living landscape that bears the marks not only of the businesses and people who work in and with it in the present, but also in the past.

Built in 1873 the Hoffman Kiln at Langcliffe was constructed for the Craven Lime Company, and, whereas most kilns have been demolished, washed away as times progress, this one is in great condition and gives you the scale of the lime extraction here.

You can simply park up, take a small walk to the site, circumnavigate it and then go inside. Take a torch!

It provided lime, which helped farmers reduce the acidity of their soil, and mortar for construction as well as tanning, textiles and in paper.

In use until 1931, the kiln had twenty-two separate burning chambers and was lined with firebricks to maintain heat. They were insulated by limestone rubble, which allowed that heat to stay inside for longer. It worked by stacking limestone and adding coal. It would take around five days for each chamber to be filled by hand.

Once lit, crushed coal would be dropped into the chamber from above through small chutes, all of which are still visible today. Flues in the walls allowed air to circulate and they were controlled from the roof. It meant that

Inside the Hoffmann Kiln.

heat could be regulated, and as one chamber burned, its neighbour would begin to heat up too – a very clever way of insuring no energy was lost in the system.

Not all the chambers were in use at the same time, as some would be allowed to cool so the lime could be manually collected and put on railways outside. It was back-breaking and dangerous work. The lime would be rock solid in the chambers and would have to be broken up in very intense heat even though the chambers were cooling.

It's difficult to picture the working conditions when you are walking inside the kiln, but it is easy to realise the scale of the job the employees had here. Outside is evidence of the railway sidings, tunnels and other workings and, just to the top left of the site, a walk down to a rival company's kiln built close by.

There are a few large-scale kilns here, much less complex than the Hoffman, but equally as impressive.

Details

The kiln is part of the Craven Lime Works Trail and can be visited, free of charge, at any time of the year. It is just north of Langcliffe, on the B6479. Go under the small railway bridge, follow the road round and turn right at the junction into a car park. Grid ref.: SD824663.

39 Victoria Cave

Dogs can be superb companions on walks and now and again can discover something a little different from a dead rabbit. In 1837, Michael Horner was out with his dogs when one chased a fox into a hole. When it failed to return, Mr Horner removed debris around the hole and crawled inside only to find coins in sediment from the Romano-British period. Excitedly, he told his boss who duly crawled inside it the following year, began digging and named it after the Queen.

What they found was one of the most historically important caves ever discovered, and one that volunteers at the Council of Northern Caving Clubs, alongside advisers from Natural England, are striving to protect, as it contains thousands of years of internationally important sediments.

As archaeologists dug down, they discovered some amazing historical items. At the topsoil, those coins from the Romano-British period were found alongside

Victoria Cave in the distance on a snowy day. (Stephen Oldfield)

other artefacts such as brooches. Pottery and decorated stones from the Iron Age followed. From there, the removal of layers of sediment brought a harpoon point from around 12,000 years ago – the first evidence of people in the Dales. Items from Neolithic man and animals were also found, including deer, horse, a reindeer antler and the complete skulls of two grizzly bears.

From there, a thick layer of glacial clay was removed to reveal narrow-nosed rhino, hippo, hyena and elephant bones. The hyena bones themselves suggest the site was used more than 130,000 years ago as their shelter and a place to hunt when the climate was much warmer than it is today.

The site is totally incredible and truly mind-boggling.

Details

Best approached from Settle, take the road towards Scaleber Force, and then follow the signposted path to Attermire Scar. While the cave is easily accessible, it is advised to stay away from the formations and note that some areas are obviously protected. Grid ref.: SD839650.

South-East

40 Hubberholme

Sometimes it is worth going off the beaten track to find a gem. While places like Ease Gill, Gaping Gill and the three peaks require walks to appreciate them fully, now and again you can just find yourself smack bang in the middle of something that sticks in the memory.

A chance drive off the B6160 near Buckden landed me in Hubberholme, and I was transfixed by the village. I parked up, got out of the car, and up to my right was a small church connected by a bridge over the River Wharfe to the George Inn. It was peaceful and refreshing.

Hubberholme was apparently a favourite place of writer and playwright J. B. Priestley, who called it the 'pleasantest place in the world'. His ashes are interned in St Michael and All Angels church, which dates back to the twelfth century. It was originally a forest chapel of Norman origin, and the original tower is evident. It also has a rood loft that dates from 1558. Only two of these survive in Yorkshire, the other being in Flamborough.

The George Inn was also frequented by Priestley and opens in the spring and summer months. It was originally a farmstead, constructed in the 1600s and was once used as the vicarage. When the vicar was there, he would place a lighted candle in the window as a signal to his congregation that he was in. That tradition is continued today whenever the Grade II listed bar is open. The candle is also used in a special ceremony known as the Hubberholme Parliament – a traditional land auction held on the first Monday of the New Year. According to the inn's website, local farmers gather to bid for 16 acres of pastureland owned by the church with the money going to those who need

Hubberholme with The George Inn on the left.

it most. 'The vicar oversees the proceedings and sits in the House of Lords (dining room),' the site reads, 'while the bidding takes place in the House of Commons (the bar). The highest bid made when the candle flickers out wins the auction.'

Down by the riverside I watch the water go past me with only its rushing, ebbing and trickle over the small rocks to keep me company. Peace and tranquillity ... as I wait for the candle to be lit.

Details
Hubberholme is off the B6160 near Buckden (grid ref.: SD926782). The inn is open in the summer months.

41 Falcon Inn

The original Woolpack in long-running soap *Emmerdale Farm* (although the 'Farm' name has now been dropped from the programme), the Falcon Inn is set in the village of Arncliffe in the valley of Littondale.

Situated at the top of the village green, the quaint pub is cosy inside with roaring fire in the winter and a large sitting room for residents. It's close by to Kilnsey Crag and other great scenic walks and has its own private fly-fishing site too on the River Skirfare.

But it's the way it serves its beer that is the real gem. The ale of choice, Timothy Taylor's Boltmaker, is poured from a jug to a glass. It's the traditional way of serving beer and keeps the ale at room temperature, ensuring it is in great condition to drink. There are also more than thirty whiskies to choose from and a guest ale on the pump.

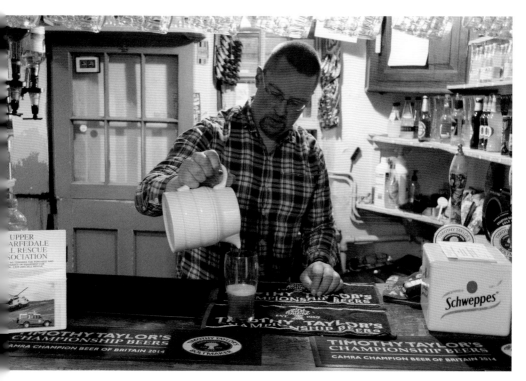

The landlord pours a Boltmaker.

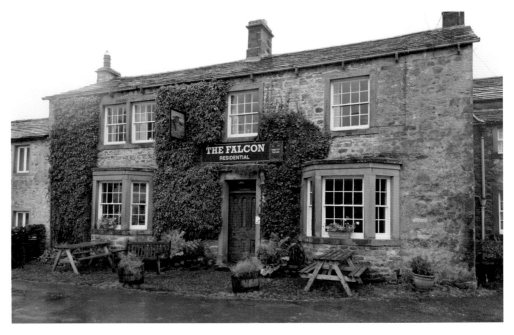

The Original Woolpack ... and the Falcon Inn.

Details

For opening hours, check the inn's website at www.thefalconinn.com. The inn's address is The Falcon Inn, Arncliffe, Littondale, Yorkshire Dales, BD23 5QE.

42 Janet's Foss

A true gem, Janet's Foss is a small waterfall and plunge pool not far from Malham and Gordale Scar.

Walking from the village and joining a very small part of the Pennine Way before turning left on the aptly named riverside path, you pass alongside Little Gordale and Stony Bank Wood before meeting Janet's Foss, which feeds Gordale Beck. During the summer, the smell of wild garlic in the wood is very special.

Janet's Foss was traditionally used for sheep dipping with farmers dosing themselves up on strong liquor to survive the cold from the waterfall.

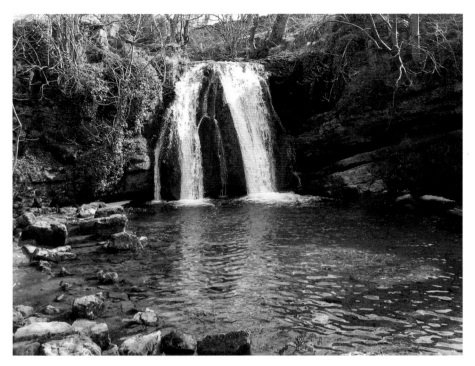

Janet's Foss.

Janet, or Jennet, refers to a fairy queen said to inhabit a small cave at the rear of the fall. Continuing with the folk tale, 'foss' is Nordic for waterfall too. You can also see tufa deposits on the rocks behind this fall – formed by calcium carbonate-rich water precipitation.

Details
Park in the national park car park (Malham, BD23 4DA). Janet's Foss is accessible all year round. Grid ref.: SD912633.

43 Gordale Scar

Turning the corner I saw the cliff rising from the left. I continued with excitement and after a few more steps I was met with a stunning view. The gorge enveloped

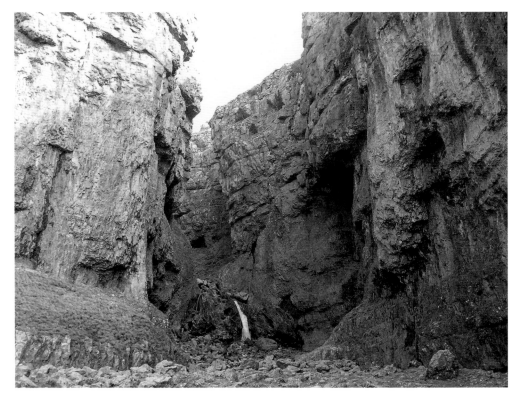

Gordale Scar just hits you.

me on both sides, stretching upwards more than 100 metres. In the centre was a waterfall making its way down tufa deposits and feeding a beck that barely seemed there over the rocks until I got closer. It was completely breathtaking and overwhelming.

Gordale Scar is a phenomenal geological site in the Yorkshire Dales that has attracted acclaim for many years. William Wordsworth wrote a sonnet about it – *At early dawn, or rather when the air / Glimmers with fading light and shadowy eve* – and Tate Britain houses paintings by James Ward and J. M. W. Turner.

It's clear the scar was formed during the ice ages, with either meltwater cutting through the rock or creating a cavern that has collapsed. Its grykes have little micro-climates for rare species of fern and other plants, and peregrine falcons call it home.

Either way, it leaves you feeling pretty inconsequential against the geology and nature around you. It houses two waterfalls over tufa deposits, and that water eventually falls over Janet's Foss into Gordale Beck and Malham Beck to form the River Aire.

It is possible to climb the waterfalls and head over the top of the scar to

Malham Tarn – ideal if you are on a circular route that takes in Janet's Foss, Gordale Scar, Malham Tarn and Malham Cove. It's steep and a little exposed but well worth the trip – especially when you turn around at the top of the first fall and view the gorge below you. Alfred Wainwright reckoned it was 20 feet for the first waterfall and then a long scree slope for the second. I'll leave you to decide how accurate that is.

Details

Park at the national park car park in Malham, BD23 4DA, and follow the route through Janet's Foss. Alternatively, camping is available at Gordale House, Malham, Skipton BD23 4DL.

44 Malham Tarn

Like Semerwater, to visit Malham Tarn on a still day, with the sun rising or setting, ideally when the temperature is dropping, can invoke feelings of fantasy, fairies and mythology. It's probably the light catching the still surface that invokes a spiritual side not found by simple walks to a local pond. This feeling even inspired Charles Kingsley's *Water Babies*, which was written here.

It is a glacial lake formed by moraine damming it as a glacier retreated, probably around 10,000 years ago. It lies on a bed of slate, and the water exits at water sinks, re-emerging at springs near Malham village that become the River Aire. It used to be twice the size, but leaching at its western shore has created Tarn Moss, a boggy area.

Owned by the National Trust, which leases part of it to the Field Studies Council, it is a sanctuary for the senses and the home of many birds and wild flowers. As a result, it is designated a Site of Special Scientific Interest (SSSI) and a Special Area of Conservation (SAC) as well as having National Nature Reserve (NNR) status and conservation importance. Traffic is also kept away from it – it's only a short walk from the nearby car park or road that leads to the Field Studies Council centre at Malham Tarn House, although the public aren't allowed to drive that far.

The NNR is 147 hectares in size and is one of the best places in the country to see fen, willow and purple moor grass as well as six species of fish.

Malham Tarn National Nature Reserve (NNR) is part of the Malham Tarn

Malham Tarn as the sun comes up.

Estate, which is owned and managed by the National Trust in partnership with their tenant farmers. The NNR is a wetland of international importance designated under the Ramsar Convention, an international treaty for the conservation of wetlands. The reserve consists of 147 hectares and is one of the best places to see a natural lime-rich lake (the tarn), raised bog, fen, willow carr and purple moor-grass. The tarn itself is the highest lake in England at 1,237 feet and that isolation and seclusion adds to its wonder. It has limestone cliffs, which reflect on the water, and a wooded area near Tarn House which used to be a shooting lodge.

The Field Studies Council uses the site to carry out research and you can see some of their equipment near the shore, down from Tarn House.

But there is so much more to the tarn that can only been seen circumnavigating it by foot – ideally early in the morning, as the sun rises, on a cold day ...

Details

Malham Tarn is best approached as part of a circular walk that takes in Gordale Scar and Malham Cove. This can be done from Malham. If you just want to visit the tarn, then the best route is up from Langcliffe following the signs to Arncliffe (and the National Trust). Park near the estate office, put some money in the honesty box and explore this fantastic woodland and tarn. Grid ref.: SD894658.

45 Malham Cove

Is there a more dramatic view than the 260 feet of limestone at Malham Cove? It's hard to believe something as naturally stunning can exist in these isles.

It is imposing from all angles, a worthy challenge for climbers, and the top provides a simply stunning vista.

Originally, a waterfall higher than the Niagara Falls flowed over Malham Cove as a glacier retreated. As it melted, it carved out the dry valley – the Watlowes – behind it and the meltwater found alternative ways to filter through the fissures instead of plunging over the top of the cove. Water that flows out of Malham Tarn takes this old meltwater course and goes underground at Water Sinks, and the theory used to be that that the water emerges at the bottom of Malham Cove. But dye testing has shown that water emerges south of Malham at Aire Head, while the cove's water is from a smelt mill some 2 miles away. Both

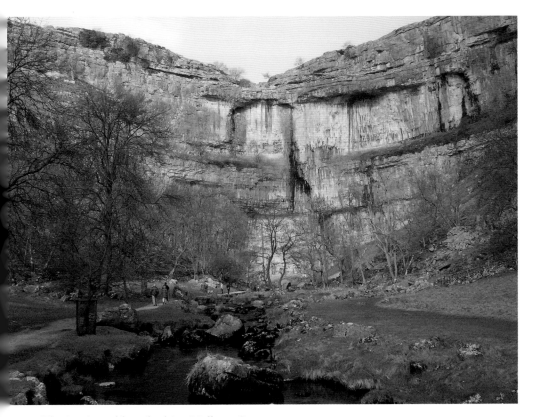

The iconic and breathtaking Malham Cove.

rivers never mix and that means there is one massive and complex cave system underneath. Divers have explored more than a mile of those passages with more discoveries waiting to be found.

Viewing Malham Cove from distance you can see the power and volume the waterfall had. There is a distinctive groove where the water fell, and the cove itself is 300 metres wide. But it is best enjoyed up close and then taking the 400 steps on the left-hand side – part of the Pennine Way – up to its top.

Details

Park at the national park car park in Malham, BD23 4DA, and walk up the road. The footpath leads to the foot of the cove.

46 Grassington

Grassington is a charming village just above the River Wharfe and a must visit on any trip to the Dales.

It is the perfect stop all year round for its environment alone – the river bustling below, green fields and plenty of historical features – but is best seen in winter when the Dickensian Festival takes over its centre and no traffic can get through.

For three Saturdays before Christmas, the village is bedecked with Christmas lights and hosts a market with shopkeepers dressed in Victorian costumes selling traditional fare and goods. In fact, Grassington was granted market town status in the thirteenth century, but stalls on the small cobbled square disappeared some 600 years later.

Today, it is the hub of a bustling community with tourism at its centre – small shops, pubs, the Grassington Folk Museum (operated by the Upper Wharfedale Museum Society), cafés and hotels replacing the old more traditional Dalean industries. Like so much of the Dales, Grassington was at the centre of lead mining.

People have lived around Grassington since prehistoric times and you can see evidence of this at Lea Green, just north of the village. It is a Scheduled Ancient Monument with well-preserved prehistoric and medieval field systems. Grass Wood to the north-west of the village, about 3 miles way, is an ancient woodland that has an Iron Age fort.

The Dales Folk Museum in Grassington.

Grassington is just above the beautiful River Wharfe.

The Yorkshire Dales National Park has a centre here too and Grassington is on the Dales Way, which takes in 80 miles of superb scenery – most along riversides – from lkley to Bowness-on-Windermere.

Details

Grassington is on the B6265 north of Skipton. The Dickensian Festival runs on the final three Saturdays before Christmas. The National Park Centre is on Hebden Road (SE003637). It operates under seasonal opening hours, so it is best to check the park's website (www.yorkshiredales.org.uk) if you plan to visit the centre itself.

The museum has a similar policy, so best to check their website before visiting (www.grassingtonfolkmuseum.org.uk). There is no charge to enter it.

47 Bolton Abbey

The Bolton Abbey estate is simply an oasis from the stresses and strains of modern-day life.

Set in 30,000 acres of stunning countryside, there is more than enough to see and do to while away the hours. Instinctively, eyes are drawn to the twelfth-century priory, the remains of which overlook the River Wharfe. Lovingly preserved, the remains are impressive from any angle and are steeped in history. However, unlike many sites of its ilk, that tradition and past isn't forced upon you with several information boards. The priory allows you to pick your path, your own route and simply discover the facts for yourself.

The land here was granted by Augustine order in 1154 by Lady Alice de Rumilly. According to local folklore, she gave the canons the land because her son, the Boy of Egremont, had drowned in the Strid. However, this is unlikely as his signature appears on the priory's deeds.

Scottish raiders damaged the site in the early fourteenth century, but the site continued as a parish church even after the dissolution of the monasteries in 1539. The other buildings had their lead roofs removed, causing the stonework to be weakened and fall down.

The priory itself has been obviously protected in recent years, but in a subtle way that doesn't detract from the dramatic setting. Stand inside its remains and

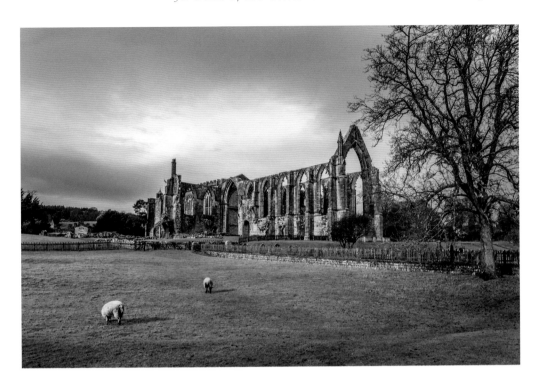

Above: Bolton Priory.

Right: Inside the Priory ruins.

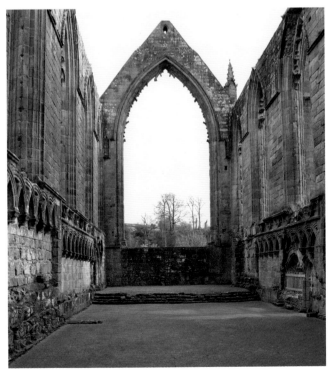

it's clear why it was built here. The vista is dramatic and the river is a superb setting. On dry days the Wharfe can be crossed via stepping stones; an iconic foreground to any photograph that has the priory in the background.

The existing church is pretty impressive too and can be visited on your trip. You enter via the unfinished West Tower, which could have looked a lot different if the Dissolution hadn't occurred. The plan was to match the splendour of the nearby Furness and Fountains Abbey, which would have seen the gothic west facade beyond the tower demolished. That would have been a shame.

In recent times, that incomplete tower was finished by Canon Slaughter. It has a pine roof, which creates a wonderful porch that echoes as soon as you enter it. Beyond lies a superb church that is in keeping with what is left of the original priory adjacent. The reader is invited to explore the rest for themselves.

The estate itself has a number of shops, tearooms and other places to visit. It has six areas of Special Scientific Interest including the Strid Wood – an ancient woodland – and is an active community. More than eighty farms are housed on its land as well as over twenty-five businesses.

Details

The estate and priory are open daily, but please be aware that this may change during the winter months, especially if you are looking for refreshment. The church is open every day from 8.30 a.m. to 5.00 p.m. in the summer and 4.00 p.m. in winter. Bolton Abbey, Skipton BD23 6AL.

48 Barden Tower

This impressive building was built for the Cliffords of Skipton in the twelfth century as a hunting lodge. It was part of six within the forest of Barden.

After the Norman conquest it became part of Robert de Romille's title of 'Honour of Skipton' and was the principal site for the administration of Barden Forest. It was also used as protection for locals when the Scots would make frequent raids into Yorkshire and beyond during the fourteenth century. Towards the end of the fifteenth century, it was extended and enlarged by Henry, 10th Lord Clifford, who also built a chapel and priest's house – the latter of which is

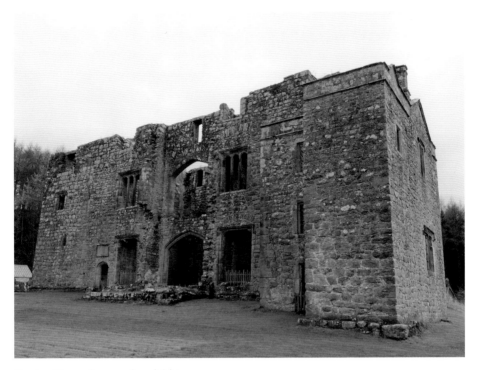

Barden Tower has a colourful history.

now a fine restaurant. After his death, the site became neglected, and it was only when Anne Clifford took over in 1643 that it was repaired and restored.

A plaque at the site reads:

This Barden Tower was repayrd by the Ladie Anne Clifford countess Dowager of Pembrokee Dorsett and Montgomery Baroness Clifford Westmerland and veseie lady of the honor of Skipton in Craven and high sherifesse by inheritance of the Countie of Westmerland in the yeares 1658 and 1659 after it had been layne ruinous ever since about 1589 when her mother lay in itt and was greate with child with her till nowe that itt was repayred by sayd lady. ISA. Chapt. 58. Ver. 12. God's name be praised!

Even after Anne's death in 1676, the site was in use – although not occupied – and in 1745 weapons of the militia were stored there to fight the Jacobite revolution. However, because it wasn't lived in it became a ruin, and towards the end of the eighteenth century its lead and roof were removed.

Now the owners, the Trustees of the Chatsworth Settlement, with the help of English Heritage, maintain the site as part of Bolton Abbey.

Details

Barden Tower is on the edge of the road between Bolton Abbey and Burnsall in the Yorkshire Dales. It is part of the Bolton Abbey Estate (Skipton, North Yorkshire, BD23 6AS) and can be visited all year round.

49 Stump Cross Caverns

Near the border of the Yorkshire Dales National Park, underneath Greenhow Hill, lie Stump Cross Caverns and their amazing formations.

Discovered in 1860 by lead miners Mark and William Newbould, they opened the caves for the public three years later after realising their commercial potential – for the princely entrance fee of 1 shilling.

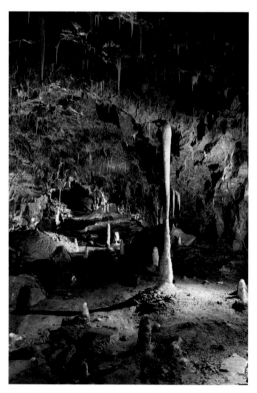

Stump Cross is full of fantastic formations. (Andy Aughey)

They were sold in 1926, with Septimus Wray and his grandson George Gill taking over years later. He installed electric lighting, and the caves remained in the family until 2003 when ownership passed to the Bowerman family.

There is around a mile of passage open to the public at present, although the caves themselves are probably close to 5 miles in length – with new discoveries continuously being found.

Caver Geoff Workman spent 105 days in Stump Cross in 1963 on his own as part of a study on the deprivation of day and night cycle. He has also spent the majority of his life digging at various points in the cave to push it further.

He discovered the Reindeer

Cavern in 1996, and this was opened to the public in 2000. Later, in 2013, the Fairy Palace Cave was opened as well. Geoff is somewhat of a star in caving circles, and a bust of his head was installed at the end of the cave in October 2014 by owners Richard and Lisa Bowman, who justly recognised this caving hero!

Like Victoria Cave, Stump Cross has had its fair share of fossil and bone finds too. The fossilised remains of a wolverine was found – effectively a giant weasel – and it probably would have entered the caves for food such as bison, of which remains have also been found. The wolverine can be seen in the visitor centre as can the Wolverine Cave where the remains were found.

Study of those bones shows that they range from 35,000 to 200,000 years old! They are truly incredible caves to visit.

Details

Stump Cross Caverns is located on the B6265 between Pateley Bridge and Grassington. The admission prices are £7.50 for adults, £4.95 for children aged between four and fourteen, and under fours are free. Grid ref.: SE089635.

50 Skipton Castle

School trips often involved visits to a ubiquitous castle complete with an enthusiastic guide and a number of tasks to complete on the journey. Thankfully, these isles have some of the finest historical embattlements in the world, and those treks as a young boy weren't in vain or viewed as boring. My childhood was before the serious digital and computer-game age, and adventure could still be found outside.

Skipton Castle is one of those places and is one of the most complete and well-preserved castles open to the public. Sitting at the top of the main street, it dominates a town that is a gem in itself. Behind its twin towers lies a fantastic building whose origins are more than 900 years old. Most of the castle can be explored, making it perfect for families and those who want to step back in time.

Robert de Romille built a timber fort in the town in around 1090, but that was soon destroyed by Scots who regularly raided northern England. Naturally, it was replaced with a stone castle with safety and defence much more in mind. The ground rose to the front and the back fell straight to the Eller Beck.

The Clifford family were given ownership by Edward II in 1310, when Robert

Clifford was appointed Lord Clifford of Skipton and Guardian of Craven. Robert began fortifying the site but was killed in the Battle of Bannockburn in 1314 with the job nowhere near complete. It fell following a three-year siege during the Civil War in 1645, which Oliver Cromwell negotiated.

After the siege, it was restored under Lady Anne Clifford, whose family's livery still flies on the castle, and the Yew tree planted in the courtyard represents the repairs she made. The tree is impressive when it blossoms and is the perfect setting to the exploration that lies beyond.

The castle is lovingly preserved in every way. You can climb from the dungeon right to the top of its towers and visit the kitchen, bedchamber and other historical areas. It is also fully roofed, making it as complete a historical venue as is possible.

Coupled with a visit to the market, which takes place on Mondays, Wednesdays, Fridays and Saturdays, and a walk along the Leeds & Liverpool Canal, it's a perfect day out.

Details

The castle is open daily from 10 a.m. (Sunday from 12 p.m.) and is closed on 25 December. The 2015 prices of entry are £7.30 for adults, £4.50 for children aged between five and seventeen, £6.50 for students and visitors aged over sixty, and children under five are free. Family tickets are also available. Skipton Castle, Skipton, North Yorkshire BD23 1AW.

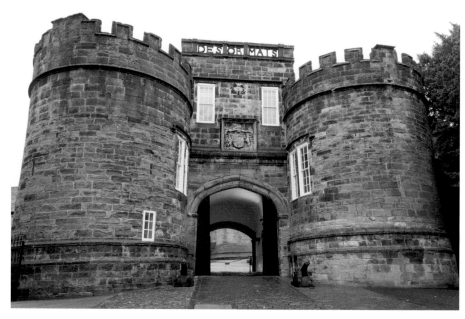

The dramatic entrance to Skipton Castle.